It Didn't Play in
PEORIA

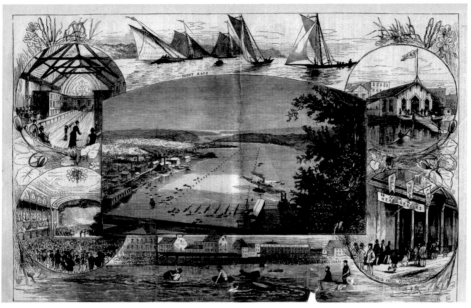

Peoria's riverfront was so well known by 1878 that Harper's Weekly *sent a reporter to cover the pictured event hosted by the Peoria M.V.A.R.A., an amateur rowing association. George A. Coffin, an illustrator for* Harpers, *found the city fascinating and proceeded to sketch the Apollo Bowling Alley, Rouse Opera House, and Peoria Boat Club. His work was so accurate that it even showed the waterfront warehouse of Allaire and Woodard. These water festivals continued in Peoria until the 1920s.*

It Didn't Play in PEORIA

Missed Chances of a Middle American Town

GREG WAHL, D.D.S. AND CHARLES BOBBITT
WITH ILLUSTRATIONS BY HUGH MCGOWAN

ARCADIA
PUBLISHING

Published by Arcadia Publishing,
Charleston SC, Chicago IL, Portsmouth NH, San Francisco CA

Printed in the United States of America

Library of Congress control number: 2009922869

For all general information contact Arcadia Publishing at:
Telephone 843-853-2070
Fax 843-853-0044
E-Mail sales@arcadiapublishing.com
For customer service and orders:
Toll-Free 1-888-313-2665

Visit us on the Internet at www.arcadiapublishing.com

To Margaret and Harry Wahl — With love always.

CONTENTS

ACKNOWLEDGMENTS

The idea for this book started at tooth #20 during a routine dental exam. Since then, we've been grateful for all the assistance we've had throughout the process of this book; so many have given generously of their time, thoughts, and materials.

We'd like to thank those who have allowed us to review their personal copies of books and other documents about Peoria: Bill Hermann, Alan Lurie, Mark Link, Jerry Driscoll, Suzanne Frye, Les Hensley, Jerry Seaman, Jim Morrow, Kathy Warner, Larry Nakamura, and Bloody Mess (you've always been a fine one). And Jim Spears for the great mid-seventies Jimmy Buffett at Robertson Memorial concert poster (when the tickets cost $3 and $4) and to the artist John McNally for the use of his artwork.

The following shared their photographs and memories with us: Peggy Leadley, Bonnie Leadley, Dwight Wistehuff, Dr. Ricia Hunt, Dave Skinder, Ron Homan, Cloyd Homan, Bob Harlan, and especially Sonny King. A special thanks goes to Carver Rudolph, son of the Krispy Kreme founder, for his thorough, incisive look at his father and the company's history.

With a history as long and varied as Peoria's, there were many paths to explore. Helping along the way with suggestions were: Jerry Turner, Tommy Smith, Gary Gooding, Bob Wilkey, Tom Carpentier, Dr. Chuck Egley, Tom Burke, Steve Cover, Dr. Jeff Baldi, Mike Poehls, Pat Spears, Steven A. Stott (an early believer), Dr. Ed Pritzker, Steve Thomas, Don Rohn, John Bannon, Jane Peverly, Dr. Ray Wojcikewych, Kelly Duchardt, Pat Pritchard, Dan Bort, Maggie Nelson, Dr. Kathy Arkwell, and Dale Page (it was a pleasure to talk with someone who has a park named after him). And Pat Sullivan for the Frazee lead.

We've had the privilege of engaging conversations with Capt. Bob Jornlin, Bill Funkhouser, Dr. Ed Bond, Dr. Bill Hall, Josh Hendrix, Steve Sonnemaker, Larry Byerly, Tim Hartnett, Gary Sandberg, Bill O'Connell, and William "Corky" Robertson, the son of The Legend. We also thank Bette and Phil Farmer for their warm hospitality and for sharing their unique view of the world and Peoria. Similarly, we appreciated the lively chats with Bill Kinison.

In discussing Peoria and the world of today, we are indebted to the following who shared their experiences and that of their various departments and units: Officer Greg Metz, CW3 Jason Rassi, First Sergeant Chris Haines, SFC Robert Groff, LCDR Dru Blanc, First Sergeant Casey Samborski, Capt. Justin Miller, TSgt Todd Pendleton, Martha Hammer, MAJ Bruce Bennett, COL Steve Konie, and COL William "Robbie" Robertson—they're keeping us safe. For the compleat policeman, Peoria had the great fortune of the long service of its retired police chief, Gary Poynter, who had a stellar career combining his sharp eye, compassion, and humility to the betterment of his community and his fellow officers. He was THE FORCE in the establishment of the Peoria Police Museum.

We depended on the professional staffs at the Peoria Public Library Reference Desk, particularly Linda Aylward and Eric Pasteur, and the Bradley University Special Collections Department, especially Sherrie Schneider and Charles Frey, for their expertise in finding rare things, including photos. Also very helpful were Williamsfield librarians Tamra Smith and Gayla Karrick. We're thankful for the assistance of Gwinnith Podeschi of the Abraham Lincoln Presidential Library in Springfield.

Thanks also to Judy Hicks, Eric Behrens, Steve Tarter, John Plevka, and Andy Kravitz of the *Journal Star* for their help in our research. We thank Bradley University's Coach Jim Les for the opportunity for picture-taking inside the Robertson Memorial Fieldhouse; he could not have been more gracious.

Through email queries, the following experts gave generous and

valuable information: Dr. Dom Pisano, David R. Larson, Dr. Craig Bethke, Dr. J.B. Freed, and Drew Bourn.

We are especially grateful to Susan Schultz for all her efforts on behalf of the book, while keeping order in the dental office. We owe much to our great friend Mike Bercos for his thoughts along the way. Dr. Jaime Cercone gave encouragement at just the right times. Bob Schroeder, as always, was a terrific help. To Jim Church, NASA's Chief Engineer for the Apollo Program, who always saw an unlimited sky. We appreciate the mentorship over the years of Dr. John Conlee of William & Mary College. Rita Carmack has our many, many thanks for reviewing the stories and for providing thoughtful comments. Likewise, we're very thankful for the effort and all the great photographs taken by Karen Camper. We want to thank our editor, Jim Kempert, for his truly steady hand at the tiller; we couldn't ask for anyone better.

We are in awe of Tim McGowan's artwork.

From the start and through it all, our deepest love and greatest gratitude go to our wives, LaDonna Bobbitt and Carole Wahl, for their cheerful and full-pitched encouragement. Without you, there is nothing.

Throughout the book, the term "Peoria" encompasses the city and/or the tri-county metropolitan area. We refer to an individual city or town within the area when possible.

Because of extensive coverage in other works, we did not delve in depth on the subjects of the Peoria whiskey trade or Caterpillar. Likewise, the many contributions to the world by Peoria's National Center for Agricultural Utilization Research, which developed the process for the mass production of penicillin in 1941 and ushered in the antibiotic pharmacopeia revolution.

INTRODUCTION

In America today, many cities thrive or fail based on their ability to provide their citizens a decent living. Along with access to food and a reasonably comfortable existence, an area's climate and landscape can be additional draws that add to a town's growth. Yet for the most part, we follow jobs today much as our ancestors followed food.

From this perspective, Peoria has it all:

- It's located near the geographic center of the continental United States, close to major transportation routes and population centers.
- It's the largest city along the Illinois River, which connects the Great Lakes to the Mississippi River.
- The land around Peoria boasts some of the world's richest soil, with farm yields that contribute mightily to the Midwest's reputation as the World's Food Basket.
- It's scenic and green. It isn't a flat prairie. In 1910, while riding along Grand View Drive in a Peoria Heights–built Glide automobile, former president Theodore Roosevelt proclaimed, "I've traveled all over the world and this is the world's most beautiful drive."
- An impressive number of Peorians have rocketed to the top of their fields and changed the world.

And Peoria *had* it all:

- It was home to a large confederation of Native Americans known as the Illini who thrived for thousands of years at the place called *Pimiteoui*, or Fat Lake, with its abundance of game and fish.

- It's the oldest settlement in the state, and one of the oldest west of the Alleghenies, with an unbroken heritage of French, English, and American rule since the late 1600s when the *voyageur* superstars paddled the Illinois.
- Breweries and distilleries flourished here as nowhere else on Earth. Quite likely every second of every day throughout the world during the Peoria whiskey baron dynasty of the late 1800s, somebody downed a Peoria spirit.
- A native son refused to be upstaged by the immortal Babe Ruth and changed professional baseball forever.
- It was once *the* American symbol of strength during economic hard times, and, of course,
- It was *the* center of entertainment: if you could make it here, you could make it anywhere.

Against this backdrop, the history of Peoria—its triumphs and downfalls—mirrors the story of Everyday America. "Will it play in Peoria?" is an instantly recognizable, world-famous phrase that has transcended its vaudeville roots and now means simply, "Will it appeal to the average American?" Indeed, for decades Peoria was the test market *nonpareil*.

But unlike other, everyday cities, Peoria came close to greatness on more than one occasion, only to settle for less, time and again. Some things, it seems, just didn't play here. This is the story of those missed chances that made Peoria what it is today, one of the most misunderstood cities in America—unappreciated for anything other than its role as the quintessential bland and boring backwater.

History, while often unkind, suggests the opposite.

And the reason for *It Didn't Play in Peoria*.

It Didn't Play in
PEORIA

1. WILL IT PLAY AT 40° LATITUDE, 89° LONGITUDE?

The Southern Cross and Old, Old Man River

In the Paleozoic Era, the tri-county region of Peoria bubbled in the equatorial tropical shoals some 500 million years before beach towels. As part of the super-continent Laurentia, it remained south of the equator for several hundred million years until the ancient landmasses that hugged the equator jostled for position in a new world order.

Laurentia, which included North America (and Peoria) along with Eastern Russia, Scotland, and Greenland, broke free and lurched north over the next 60-plus million years.

After several hundred million more years of global warming, a cold wind chilled the planet, ushering in another epoch—the Pliocene. The change seemed subtle enough: a couple of degrees cooler every few thousand years, a little drier, and the advent of seasons in what would be Peoria—now far away from its equatorial cradle and settling down around 40 degrees north latitude.

Around five million years ago, the future site of Peoria nestled on the west bank of the Ancient Mississippi River, an area of hilly canyons, craggy bluffs, and warm breezes. To the east, the headwater of the River Teays began its cut through the Blue Ridge Mountains of northwest North Carolina. It flowed north through West Virginia to Chillicothe, Ohio, where it then ran west across the northern third of Ohio and Indiana. By co-opting major tributary branches along the way, much of the eastern United States drained into it.

At the Illinois border, the Teays picked up not one, but two new names—the Mahomet or the Mahomet-Teays. It kept its westward course until, south of Peoria near present-day Lewistown, it twinned with the Ancient Mississippi. The swollen, melded rivers turned

southwest toward the southern tip of Illinois, near St. Louis, where they emptied into the ancient northern embayment of the Gulf of Mexico.

At its grandest, at the end of the Pliocene, the River Teays averaged one to two miles across and over 900 feet deep—that was two million years ago.

If the late Pliocene wasn't a lot of laughs, the next one, the Pleistocene Epoch, the "Ice Age," had a real growl for the temperate zones of the prehistoric world. Mercifully, it didn't last long, going from 1.8 million to 10,000 years ago. And the lumbering continental ice sheets, covering a yard or two a day, gave plenty of notice that they were in the neighborhood. Throughout the Pleistocene, there were 14 to 18 ice ages with moderating interglacial periods (paleo-global warming) in between.

The Peoria area itself succumbed to several ice sheets, the most significant being the Illinoian, which covered 90 percent of the state of Illinois. The glacier, nature's rolling pin, kneaded and flattened rugged topography into a prairie veldt with kinder, gentler hills.

Before the glaciations, Peoria had the more rugged terrain and steep cliffs of today's Galena in the northwest corner of the state or of southern Illinois, both of which were untouched by glaciers.

Besides rearranging the prehistoric landscape, the continental ice sheets also changed the course of rivers and lakes. Even the 1,000-mile long, three million-year-old Teays fragmented under the crush of the ice age glaciers with a portion shunted south to become the Ohio River.

The Ancient Mississippi moved away from the future Peoria, going west almost 100 miles to its present location after the Illinoian glacier chocked the river at Rock Island. After the glacial meltdown, the Illinois River generally filled in the old Mississippi riverbed from Hennepin south before emptying into Old Man River's current channel just north of St. Louis, thereby uniting the old with the new.

Entombed by time and sediment below the muddy gorp of the latter-day Illinois lies the relic bedrock of the primordial Mississippi, America's Great River.

Chicago, Who's Your Daddy?

On the Caribbean island of Hispaniola, on its northwestern side, sat Saint Domingue, the claw-shaped jewel of 1700s France, where plantations yielded their white gold, sugarcane. Beyond the harbor bustle of Saint-Marc, a love between a French sailor and a freed African woman named Suzanne rose above the bay, Golfe de le Gonave; the year didn't seem important, though most believed it was somewhere around 1745.

Suzanne gave birth to a babe, the future Peorian Jean Baptiste Pointe DuSable. While a child, DuSable left the island with his seafaring father on a ship around 1755, heading to the Old World and cooler winds. As most things DuSable, his mother apparently died before the ship sailed, possibly killed by Spanish pirates during a raid of the coast.

The ten-year-old stepped ashore in France where he received, thanks to his father, a rarity of the times—a quality, formal education in Paris. He developed an appreciation for the arts; before he turned 20, he owned 23 European masterpieces and spoke the handy languages of imperialism: English, French, and Spanish.

Years later he added a few Native American dialects to his collection.

Genteel and young, DuSable returned to the island of his birth at the age of 20 and took passage on his father's ship, making his way from Saint Domingue north to New Orleans. When the ship sank along the way, another merchant ship rescued the injured DuSable and took him to the Crescent City, but he found he needed a priest more urgently than medical attention—to hide him from the Spanish who ruled Louisiana at the time. Without his identification papers that went down with the ship, DuSable, as a black man, couldn't walk the streets free; he hid within the shadows of churches until, at the right time, he escaped the Big Easy.

Finding the coast a menace to his freedom, DuSable went upstream, up the Mississippi. He took the Illinois River toward the northeast, wandered into the French village of Old Peoria, and stayed. He added

"landowner" to his list of pioneering skills when, on March 13, 1773, he bought a house and lot from Jean Baptiste Maillet in Old Peoria Fort and Village. He then joined a local Potawatomi tribe and took a maiden, the chief's daughter Kittihawa, as his bride. He called her Catherine.

DuSable, being an amiable sort, soon attracted trappers and traders throughout the Upper Louisiana Territory as they passed along the bountiful countryside of Old Peoria. Besides his trading post, he farmed some 30 rich-soiled acres and was father to a daughter named Suzanne, after his mother, and a son, Jean.

With all going so well in Peoria, DuSable, following his nomadic spirit, suddenly left the village and headed to the northeast. Sometime between 1779 and 1784 he walked along a river that joined an ocean-sized lake; a place the nearby Indian tribes regarded as an open, marshy cesspool which they called *Eschikagou*—the Land of Wild Onions, or Land of Bad Smells.

Yet despite the smell DuSable saw potential, something no one else had. So at the mouth of the Eschikagou River on its north bank, he staked his claim, the first non–Native American squatter in the history of Chicago. Before long, and with a mogul's vision, the Peorian not only had a large log house (near today's Magnificent Mile on Michigan Avenue), but also the first "mall" of the future Second City with a trading post, dairy farm, bakery, stable, hen house, smokehouse, woodshed, and other outbuildings.

While his trading and supply business boomed and, like his downstate operation, became a stop for the trappers throughout the territory, DuSable also received an additional 800 acres in Peoria from a post-Revolutionary United States commission to promote homesteading on the frontier, based on his testimony that he had resided with his family in the village before and after 1783 on a 30 acre farm that he had bought and improved. He was, by all frontier measures, a rich, popular, and successful man who attracted others to settle the swamp. And the years passed.

On October 8, 1796, DuSable's Peoria-born daughter Suzanne gave birth to a girl, Chicago's firstborn child.

Still, despite it all, Chicago's Daddy, at the start of the new century in 1800, seemed restless for his Peoria days and sold all of his holdings for $1,200 to Jean La Lime. He returned to central Illinois by the trail he knew well without looking back at the future city he had founded.

He spent another decade or so in Peoria, tending to his trading, farming, and local interests. When his son Jean Jr. died in 1813 in St. Charles, Missouri, west of St. Louis, he moved there to raise his granddaughter. After an adventurous lifetime and a couple of fortunes made, Jean Baptiste Pointe DuSable died a pauper in St. Charles in 1818—the same year that Illinois became a state.

The Midwest colossus of Chicago finally recognized as its first settler Haitian-born and former Peorian Jean Baptiste Pointe DuSable on October 25, 1968, denying the claims of John Kinzie (though in consolation Kinzie has the honor of being the first white male settler who came from Quebec as a British citizen and he also became the second owner of DuSable's Chicago homestead).

Less than a decade after Chicago's founder died and Illinois became a state, Peoria again figured in the toddling village—this time raising it. In January 1825, the state created Peoria County, which governed most of the northern part of the state, including Chicago. The downstate county guided with a sure hand for six years until 1831, when Peoria allowed Chicago, upon the formation of Cook County, to go into the world.

It did.

2. GRAVE ROBBING DIDN'T PLAY IN PEORIA

Nulla Dies Sine Linea

They sweated under the November quarter moon even though the grave was a loose-packed mound—Harker had seen to that with his burial crew earlier in the day. The tasty pint was all he wanted; he could've demanded more, but he liked the doc. He knew Coop would always be there to fix all his ails; besides, with all that cutting he does night and day . . . nobody in Peoria or the forty counties knew an eye from an elbow better than Doc Cooper. Everybody said so.

It took all three men to drag the drifter's large body from the oversized, simple casket. Their swearing was louder than their grunts until they realized they might be heard beyond the hedgerow that rimmed the cemetery. And the coppers made their rounds a little closer to the graveyards once a good chill chattered their bones, looking for those seasonals—those grave robbers. The nip in the air seemed to improve their hearing as well.

The men swore themselves to silence. They could chat with Harker in the morning anyway and complain about the job, digging out a grave that seemed bigger than Peoriory Lake.

The most dangerous part was the trip to Doc Cooper's office, which happened to be a three-story brick building in downtown Peoria. Late at night, without the noise of city life to dampen them, the ghastly creaks of the wagon bounced off the store fronts and boomed in the dead cold air, creating unwanted echoes for the diggers who had hoped their passage wouldn't stir John Law or worse, vigilantes.

And all this in the name of medicine.

Born in Somerville, Ohio, on November 25, 1820 to a Quaker family of nine children, Elias Samuel Cooper was the second of three sons. Eager to work and blessed with a rambunctious mind, young Elias watched wagon after wagon go by, following the sun's path west; at night he'd dream of the pioneers always smiling in the light that was always shining. At 18, in 1838, he followed his older brother Esaias into medicine as apprentice to a Dr. Waugh of Indiana.

A year or so later the Cooper brothers, in the way of many nineteenth century physicians, hung out their shingle in Greenville, Indiana, and practiced medicine together until 1843.

Restless and inching ever westward, Elias moved next to Danville, Illinois—a town near the Indiana border—where his talent for surgery surfaced. Also surfacing were whispers of corpses coming out of the ground and landing on his dissecting table, so it wasn't long, about a year in fact, before Doc Cooper again trekked toward the sun . . . to the west central Illinois town of Peoria and its promise of surgeries from morning till night.

Peoria was a town of less than 2,000 at the eastern fringe of the frontier, but bustling toward its heyday when Doc Cooper arrived in 1844. As the major port on the Illinois River, the commerce between Chicago and St. Louis made the town docks dizzy with ships. There were plenty of injuries from scuffles and accidents involving the transients, Peorians, or combinations of both—with Doc Cooper, blade in hand, at the ready. Defiant of sleep, with skills in the surgical arts honed by fanatical study of anatomy (over his bed he'd written the words of the ancient Greek painter Appelles: *Nulla dies sine linea*, "No day without a line"), the doctor soon had a blazing practice of grateful patients.

Until the plague of envy overwhelmed some of Cooper's colleagues, who, by raising the specter of grave robbing, hoped to shred his reputation. Or better, encourage him to leave town in the gloom of night, smothered under the same tarp his dead arrived under.

By 1846 there wasn't any doubt Cooper taught anatomy classes,

since he placed notices in the local papers for students and doctors who wanted to improve their knowledge of the human body and hone their surgical skills to join him in his third floor dissecting lab. The knowledge was sorely needed. After all, a doctor could only rely so much on comparative anatomy. But until the end of the 1800s, American law prohibited human dissection for medical science except in the cases of criminals executed by the state, usually by hanging. Studying a criminal's remains on the slab was the final slap of capital punishment: a desecration of the body meted out by men of science.

Since many more dissections took place than executions, grave robbing was a necessary but provocative trade, one that could agitate people into a riotous frenzy. Over a dozen "Doctor Riots" had occurred in the United States since 1765. They were one-sided affairs where the outnumbered physicians, armed only with scalpels, were no match for the madness of the mob.

So the jealous physicians of Peoria convinced the press to write tales of the lurid business of Dr. Elias Samuel Cooper stealing the bodies of Peorians' loved ones. The near-daily diatribes in the Peoria papers worked their impugning magic—the public looked around for a sturdy tree limb for the anatomist, but first they had a town meeting to vent their disgust and, with luck, run the doctor out of town before they had to string him up. Posted around the city were handbills touting, "Rally to the Rescue of the Graves of Your Friends," that captured the crowd's subtle mood.

Never one to step away from his professional passions, Doc Cooper went to the meeting with his friends, known as "Cooperites," including one who played a drunken buffoon and made a mockery of the rally's organizers, sending the townsfolk home rather upbeat about their Dr. Cooper. Public opinion swayed back to his favor.

With their public opinion campaign in shambles, the doctors resorted to the courts. For three years, over and over, motion after motion, Dr. Cooper acquitted himself with compelling arguments while the plaintiffs offered innuendo unanchored by evidence.

But Cooper's nature ensured that his angry adversaries would have other chances in the future.

In the meantime, he continued his call for a doctors association where there would be a free flow of scientific knowledge among practitioners and improvement in the standard of medical care. In 1846, Peoria physicians were most likely the first to form a medical alliance in the state of Illinois—two years ahead of the founding of the American Medical Association. The Peorians would restructure their society twice in the next two years, forming a permanent district society on April 19, 1848, as a chapter of the national AMA. Cooper was among the earliest members and a constant contributor of clinical papers at their meetings.

On June 4, 1850, Elias Cooper was one of the original 49 members at the founding of the Illinois State Medical Society and served on the society's Standing Committee on Surgery, even though he hadn't gone to medical school yet (in his first published paper in 1849, Cooper had affixed "M.D." to his name, a degree he apparently pulled from the air). By late 1850, he started the requisite four-and-a-half month course at St. Louis University and earned his medical degree in March of 1851. During that time in Peoria, on January 19, 1851, a couple of convicted murderers became the town's first legal hangings—an event witnessed by 10,000 people. (It wouldn't have surprised some of the more enlightened in the crowd to see Cooper atop the gallows, sawing madly at the ropes, and whisking the fresh cadavers away to his third floor slaughterhouse.)

Indeed, prior to the executions he had petitioned the court for the remains; he wasn't about to let an opportunity for *legal* dissection slip by. But with thousands of morbid stalkers around (some with such explosive remorse and needing to absolve themselves by an act of penance even if it meant the complete dismemberment of a certain anatomist), Cooper waited until late into the icy night to have the bodies hauled to the unlit back stairwell of his office.

At the first annual Illinois State Medical Society meeting, held in

June of 1851 in Peoria, Dr. Cooper proposed a look at the issue of legal dissection by a three-man committee; given his zeal, the society named him the chairman. He then presented two papers, including one on the use and danger of chloroform anesthesia based on 79 operations he had performed.

It was quite a first half of 1851 for the doctor and he wasn't through.

In September he opened Peoria's first hospital—The Peoria Eye Infirmary and Orthopedic Institute—on the west edge of town where his night wagons could rattle along without stirring the vigilante souls of downtown . . . even if a couple of shovels fell off. And thanks to newspaper advertising of the unique surgical services offered (along with a list of references that included, among others, "A. Lincoln" of Springfield), the hospital's success was immediate and profound, drawing patients from all the adjacent states of the Old Northwest Territory. Unfortunately the same ads also rankled his old enemies, who vowed a holy war over Cooper's unprofessional hucksterism.

At the June 1, 1853 meeting of the Peoria Medical Society, a couple of physicians brought charges of unethical advertising of hospital services against Cooper and he was a pariah again—this time with organized medicine, an institution he championed and revered. The meeting ended in a wash, with offsetting resolutions in the record: the first one called for a censure of Cooper for his unprofessional advertising while the second acknowledged his contrition and a promise to sin no more; his *mea maxima culpa* sated his foes who then withdrew their damnation of him.

Still, when the state medical society met in Chicago less than a week later, a few of Cooper's enemies were unable to wrest from their hearts the hope of his expulsion from a medical society—neighborhood, state, national—it didn't matter what society just as long as he ended up *disgraced*. But they returned to Peoria without his scalp; he had survived once more.

In fact, within a year, at the 1854 St. Louis meeting of the AMA, the national leadership had such respect for Cooper that they named him chairman of the Committee on Orthopaedics, an honor usually reserved for surgeons from large metropolises, not little towns in west central Illinois.

The year 1854 was also Cooper's last in Peoria.

Whether it was the onset of facial tics, the lack of challenges for someone at the top of his surgical game, or the fevered urge to open his own medical school, Dr. Elias Cooper felt a tug toward California, specifically San Francisco. To prepare for the western move, he added scholarly gravitas to his already impressive resume with calculated visits, from October to December 1854, to the famous surgeons of New York, London, and Paris. There were also trips to Europe's venerated colleges of medicine, which would serve later as models for his own medical school.

Wild with plans, Dr. Cooper returned briefly to Peoria in January 1855. By mid-April he had disposed of his hospital along with his practice and left without a word.

Cooper arrived in San Francisco by ship at the end of May and saw a city that was a mirror of himself: hectic. And, though far grander in scale, San Francisco shared a similarity with Peoria—rolling hills that overlooked water. And both were rough, rogue towns, too. He was home again.

He wasted no time.

Before the city knew what hit it, he had opened the Cooper's Eye, Ear, and Orthopaedic Infirmary in July 1855—five weeks after his landfall—along with an advertising blitz that had the coast reeling, and which earned him fresh vitriol among many of his new California colleagues.

At the same time as the opening of his infirmary, and true to his commitment to education, he offered a course in clinical instruction for the region's physicians. Rather than endearing him to his fellow doctors, the old guard viewed his door-kicking entrance into their

community as an egregious insult to their seniority. Even his name, E.S. Cooper, A.M., M.D., on the cards announcing his course raised the hackles of some in the profession: Where did he receive his masters degree . . . and when? Cooper ignored the skeptics, leaving them to wonder whether he appended a sham degree to further his credentials as an educator.

In August 1855, as corresponding secretary for his newly-formed San Francisco Medico-Chirurgical Association—and rival to the staid San Francisco Pathological Society—Cooper spontaneously pushed for a state medical association with an aggressive letter campaign to his counterpart, Dr. Thomas Logan of the Sacramento Medical Society. Within six months, by March 1856, California had its first statewide medical organization, which then elected Cooper its vice president. At this seminal session, just as he had done with the Illinois Medical Society less than six years earlier, Cooper introduced a bill to allow the donation of bodies for dissection; this time the Committee on Legislation refused to even consider or endorse it.

The San Francisco Medico-Chirurgical Association, at its second annual meeting on July 7, 1856, elected Cooper as its president— heady exposure for a newcomer with less than 14 months in the city. Not done for the year, he became acting president of the California State Medical Society when its first president, Dr. B.F. Keene, died in early September.

It would be his highest post in organized medicine.

In July 1857, the local society permitted him to make a few copies of a surgical case study he had presented to them. However, he had an additional 5,500 printed, all bearing the society's underwritten imprimatur and Cooper's wild-eyed intent toward wide distribution throughout the west and maybe the whole country. There was a hitch: the Publication Committee of the San Francisco Medico-Chirurgical Association did not authorize that many copies, which they felt smacked of grand puffery. Over the next few months they demanded an explanation from him, but he refused until an October

meeting. When he finally defended himself, the committee found his reasons unacceptable and, unwilling to change, he left in a huff. The association—the very one he started—expelled him.

A month later, in November, he performed the first successful caesarian operation in California. Less than a year later, in 1858, he was party to the first malpractice lawsuit in San Francisco from the same caesarian surgery.

The patient, a Mrs. Hodge, was in fine recovery until a Dr. Wooster, who was her attending doctor during her labor, convinced her that she had "hysteria" due to Dr. Cooper's quick go at her with his knife; Wooster insisted that most good doctors would've exercised more caution and not assaulted her so quickly with the blade.

Cooper's lawyer pointed out the vexatious envy of the plaintiff's phalanx of doctors, especially the red-faced, sneering Wooster. The trial ended in December with a split jury, which Cooper saw as a victory.

As was his nature, in the summer of 1858, between fevered dueling with doctors in the letters section of the San Francisco newspapers and a nervy trial, he pitched the idea of a medical school to the University of Pacific; in three months it was a done deal and the first medical school west of Iowa opened its doors in May 1859. Cooper served as professor of anatomy and surgery; he also led in school pep rallies.

Besides running a medical school, he needed another outlet like publishing a medical journal, which he did in January 1860 with the *San Francisco Medical Press*.

By early 1862, a left-sided facial paralysis along with a severe, ranging neuralgia of his extremities slowed and then crippled Cooper, who could no longer teach. He spent his last days at home with his nephew, fellow surgical professor, and the keeper of the Cooper flame, Dr. Levi Cooper Lane.

It was during this time that Cooper performed his last surgery—on himself.

According to his nephew, he yielded at last to the intense pain in his leg and ligated his own femoral artery. Dr. Lane said his uncle

recounted that he felt "much excitement" during the surgery and later that it had a "beneficial effect." However, the remission didn't last and the pain worsened into hellish intractability.

Before his death, Cooper, ever the scientist, detailed his own dissection, hoping for a diagnosis that would help future doctors treat patients with a similar condition. He died on October 13, 1862 at the age of 42.

Yet irony hounded him even in death, starting with his internment, for the most part, at the Lone Mountain Cemetery—the same bone orchard that the San Francisco newspapers accused him of grave robbing in the past. "For the most part," because Dr. Lane had his uncle's brain and heart extracted and placed in separate jars that were mounted together onto a pedestal that he kept in a private sanctum of the medical school's museum. In 1946, Dr. Cooper's remains were removed—not robbed—to Laurel Hill Mound of Cypress Lawn Memorial Park in Colma.

The final twist came in 1979 when the display of Elias Cooper's heart and brain went missing from the attic of the old Lane Library of Stanford University Medical School. It's still out there, somewhere.

For Dr. Elias Samuel Cooper, Peoria served as a worthy testing ground to hone his surgical skills, along with the seasoning he gained from the constant parrying with his fellow doctors.

Today the world-esteemed Stanford University School of Medicine, founded in 1909, can trace its lineage through the Cooper Medical College (1882–1909, with its last graduation ceremony in 1912), the Medical College of the Pacific (revived by Dr. Levi Cooper Lane, 1870–1882), and the University of Pacific Medical Department (1858–1864), all the way back to Doc Cooper, visionary Peoria surgeon and grave robber.

In the end, Peoria's loss was Stanford's gain.

A Very Normal Spy Story

In the mid-1850s, Illinois educators saw a need for a normal school—a college to provide standardized teacher education. Later, when the federal government furnished the funds, the normal school would become a state university. In fact, the Illinois State Normal University would become America's only normal school known as a university.

By the force of Peorian Charles E. Hovey's leadership as president of the Illinois State Teachers Association, the state government agreed to fund the college with a bidding war among towns interested in the new school. The finalists that early spring of 1857 were Batavia, Washington, Bloomington, and the big dog—Peoria. Feet paced the floors as the May 7 deadline for the opening of the sealed bids approached.

On Friday, May 3, 1857, John Eberhart, more than ever before, wanted out of that whiskey town of Peoria. Nettled by an urge to make time, he rode east toward Bloomington. Every mile that passed his back meant the sooner he'd share the secret, the burden. Then what?

On and on he went, scarcely looking at the central Illinois prairie that passed by.

An eighty thousand dollar bid. Damn Peoria!

It was a stroke of luck that he had met an old friend, a fellow teacher, on the downtown streets of Peoria. It was even better luck when his friend had whispered how much Peoria had bid to be the site for the recently-appropriated state normal school.

You might as well name Satan the principal if you're going to have the normal college in that . . . that river town.

The frailty that kept Eberhart out of the classroom didn't slow him down as he walked toward Jesse Fell's home in North Bloomington, an area also known as The Junction. In the past few years Fell championed the idea of a public teaching college, and that Bloomington was the right spot for it. Eberhart, who shared Fell's convictions, unloaded his news about Peoria except for the exact amount of the bid—he wouldn't be a snitch; it was beneath a principled man. Instead, he said Bloomington's bid had to be "raised."

From Eberhart's manner, Fell knew he held a worthless offer. He upped the bid; Eberhart shook his head. He upped it another $5,000. Again, no. After a couple more guesses without anything more than a "no," Fell had a gloomy feeling: Peoria's offer may be out of reach.

He upped it again, this time by $25,000.

At last Eberhart said yes, such a bid would exceed Peoria's. Fell, relieved the guessing game was over, said he'd see to it that the Bloomington subscriptions exceeded their western neighbor's incredible bid.

The real fear, though, was time. In less than four days, on Tuesday, May 7, the Illinois State Normal University Committee on Location would open the sealed bids . . . in Peoria.

The city had it all. It reeked of wealth, thanks to its distilleries and breweries, along with everything—saloons, brothels, and gambling—that went with it. It had the pile-driving Charles Hovey, the Vermont transplant and superintendent of its schools, who headed the State Teachers' Association (chartered in December, 1853) as its first president. He was also a loud member of the Committee on Location, always promoting his town, which was the largest one in the running.

The Junction men couldn't dawdle; it was time to saddle up. Eberhart headed out of Bloomington again, boarding a northbound train for Chicago, charged by Fell to herd three board members of the location committee into the Bloomington camp. Meanwhile, based on Eberhart's spying, Fell hitched his buggy to Old Tom, hoping he had enough horse to make it to Peoria in time for the evening's public

forum on the school site. He had to find out if Hovey and friends planned on fetching more cash for their bid, which would put the school beyond Bloomington's reach.

Old Tom came through.

Chairman Hovey spotted Fell in the crowd, but he wasn't one to hide his cards or his agenda; besides, there just wasn't any time left for Bloomington. At the meeting the city's board members celebrated their $80,000 bid as a de facto win, with any remaining debate centered on the yawning aspects of building their normal university. Fell left the hall determined to make it back to Bloomington in time. Would Old Tom have enough fury in him for a fast trot back to the barn?

John Eberhart knew Chicago because of the teacher institutes he had given there and, well, throughout the state; such lecturing had convinced him of the necessity of a state college to provide standardized education for teachers. And when he talked of the merits of locating of the normal university in the Bloomington area with the three Chicagoans on the Committee on Location, he was the expert who knew the state cold. He spoke about the importance of establishing the normal school in a college community that already had a learning atmosphere, such as Bloomington had with Wesleyan College; along with the ease of intrastate transportation for students and faculty like The Junction of North Bloomington, with its intersection of the Illinois Central and the Chicago and Alton railroads.

Eberhart could enjoy his ride back to Bloomington because all three Chicago board members sided with The Junction.

While Eberhart worked Chicago, Fell spent the weekend of May 4–5 without his feet touching the ground as he cajoled subscribers to add to their totals. The specter of students of the normal university drunk and crawling on the godless Peoria streets was easy to imagine if Bloomington lost. Yet raising $25,000—a 50 percent increase in subscriptions already pledged—in two days, seemed impossible.

For Fell and the others, the weekend promised a biblical struggle: The worthy against Sodom and Gomorrah with a little of David and Goliath tossed in.

By late Saturday, with Fell plowing another $2,000 into his personal subscription, the private donations swelled to $71,000. Next, Fell went to the three McLean County commissioners and persuaded them to match the pledges of their citizens. It was a daring risk for the commissioners, who faced a political backlash if the university failed to bring prosperity to the community and the county.

Bloomington sealed its bid—and its fate—on Monday, May 6, just as the train from Springfield—with the location committee members on board—whistled its arrival. The committeemen wanted to look at the prospective locales as they made their way to Peoria and the opening of the bids the next afternoon; only Batavia, west of Chicago, missed a review.

At the Junction, the drumming storms of the last several days made buggy travel to the proffered school sites tough and fitful for the visitors; though testy, the state officials went to each of the Bloomington parcels. And when they stayed over that night, no one could read which way the committee leaned.

They'd know in less than 24 hours anyway.

On Tuesday, May 7, The delegates boarded the train heading west to Peoria with the Bloomington supporters and reporters stowed among them. The next stop was Washington, a town east of the Illinois River and northeast of Peoria, with its bid that included a parcel of land and a three story building for the university; it was a quick look.

The train chugged into Peoria a couple of hours before the 3:00 p.m. deadline, which allowed plenty of time to view the city's offerings; then everyone went to the courthouse.

While supporters of the competing towns rallied around the grounds of the Peoria County Courthouse, the Committee on Location board members played the last hand of the Illinois State Normal University mystery and opened the bids. The first one, Batavia, offered a total

bid of $45,000. Next was Washington's $20,000 offer, which kept Batavia in the lead, but not for long. The Big Town, Peoria, dropped its $80,000 boodle with wide beams and smirks among its patrons even though there was one sealed envelope left. And no one seemed to notice the subtle glances of the Bloomington faction, glimpses that should have been downcast after the Peoria offer.

The board opened the final envelope and announced the Bloomington offer: $141,000.

At first there was disbelief, accompanied by flagging jaws among the Peoria cartel. Overwhelmed by $61,000 by those righteous folks to the east, it was Peoria's worst fear: an amount so large that they couldn't counter, or nitpick about the merits of each aspect of the bid in the hope of convincing the committee to accept the lower, but "stronger" offer.

Trying to grab the school before it slipped away forever, Hovey the Peorian quickly demanded that Bloomington guarantee what he felt was a shaky pledge by McLean County. And he wanted that document within 60 days. If Bloomington failed to deliver, then Peoria would break ground for the college.

Ignoring Hovey's implication that their pledge had fluff in it, the Bloomington board members, including Daniel Wilkens, readily agreed.

Surrounded by friends and supporters, a weary Jesse Fell could now breathe easy; the normal university, his baby, was coming home. After the weekend he had, finding enough cash for the county would be a stroll in the park.

On May 15, one week later, attorney Abraham Lincoln prepared the $70,000 Bloomington bond guarantee for the Board of Education; it was money in the bank.

During the last stages of the battle for the normal school, Fell opened a second front—the search for the college's first principal, or president. He had hoped his good friend Horace Mann would accept the position. Mann, already a legend as America's leading voice for public education and an ardent abolitionist, was the principal at

Antioch College in Ohio, but he had eyes that had shifted westward.

Fell and Eberhart wrote often to the icon, working out the details of Mann's move to the Junction. First, Mann asked for a yearly salary of $2,500; Fell again went to the till and secured the money. Next, Mann said he was weary of the strife he had endured during his career and felt his confirmation for the position must be unanimous by the state board.

After losing the normal university to Bloomington, Peoria educators chaffed not only at the loss of the school, but also at the loss of their voice in the governing of it. When rumors swirled around the River City that Horace Mann might become the college's head, they mounted protests all the way to Jesse Fell's door.

But the rants were nothing compared to a hallway chat a Peoria teacher had with John Eberhart about the hiring of Mann: the Peorian whispered if they hired that abolitionist, Mann, "We'll kill him." Then the educator offered a way to keep Mann alive: Make an Illinoisan, a Peorian, the university's principal. After all, he continued—with Eberhart's back against the wall—Bloomington owed them that much, since The Junction stole the school.

With a death threat added to the list of offers by the Illinois school, Horace Mann bowed out—by return mail.

The next best candidate just happened to be Peoria's Charles E. Hovey. The board tabbed him to lead the Illinois State Normal University. It was a win for everyone, and without bloodshed.

For his part in the founding of the university, Old Tom never received any odes. Just oats, which suited him fine.

Are You Nuts?

Toward the end of the nineteenth century, Peoria had another real opportunity for a new major university, The Corrington Institute and University to complement the fledgling Bradley Polytechnic Institute (1897). Combined with the earlier—and missed—opportunities to host

the Illinois State Normal University and possibly a "Cooper Medical College," what a wealth of academia the city could have offered.

Washington Corrington, born in Ohio's Warren County in 1812, yearned for honest dirt under his fingernails after years as a merchant and looked west. In 1846 he hitched his dreams to the family wagon and moved to Richwoods Township at the north edge of Peoria, where the unschooled 34-year-old signed a note for 40 acres of land.

And the farming began.

Over the decades, Corrington bought more earth—some 480 acres more. Today, the old Corrington farm would be flanked by Lake Street to the north, Nebraska Avenue to the south, Prospect Avenue to the east, and University Street to the west. He also owned land in neighboring Knox and Stark counties as well as property in Iowa and Florida.

After ensuring his children were well-educated, he was no longer content with just cleaning his fingernails at the day's end and, in 1856, he sought the advice of Illinois Senator Stephen A. Douglas on how to start a "career of reading." The Little Giant, despite a busy campaign for the Democratic nomination for the presidency, sent Corrington a pamphlet of the publications of the Smithsonian Institute. From that leaflet, the uneducated farmer unleashed a wolfish reading passion for the rest of his life with a bent toward magazines like *Popular Science Monthly*.

By bettering himself through reading, Corrington spent much of the last half of his life leading. He became a Richwoods Township supervisor and the township's treasurer of schools. In a small township way, he had become a "Richwoods Abe"—like the president he admired—self-taught, self-reliant, and a caring leader of the people.

Washington Corrington, through a will filed October 7, 1895, planned for a future without him by apportioning a part of his wealth

toward the founding of the Corrington Institute and University in Peoria. The purpose of the university would be to "Collect and diffuse knowledge among mankind" and it would be "co-educational, non-sectarian, and non-partisan in all departments." And it would be a liberal arts and science university, but *no* football team. The estate would set aside a portion of his property and $1 million for the school; he named three trustees to oversee the founding.

The will also dispersed his remaining wealth to his wife, a married daughter who lived in Florida, and a grandson. Corrington's four other children would not have a share in the estate because he felt they were well-off financially.

A couple years later, in August 1897, he amended his will to exclude monies to his heirs and added three more trustees for the founding of the university with the proviso that the six named trustees would appoint three more to the board. The board would govern the estate and allow it to grow to $1.5 million before any groundbreaking for the school.

At this point the generous philanthropy highlighted in his will made noise. According to the August 21, 1897 issue of *The Outlook*, a national religious weekly, Corrington wanted others to have a chance "to get educational advantages, and I have determined to devote all that I own to the establishment of a university." The weekly noted that some local educators had tried convincing Corrington to donate to an existing college such as the Bradley Polytechnic Institute just founded by millionaire Lydia Moss Bradley. But the farmer held fast to his own vision. Even the *New York Times* on August 8, 1897 ran an article, "For a University at Peoria Washington Corrington is said to have provided for one in his will," that reviewed the will's salient points.

He spent the last years of his life between Peoria and winters in Florida with his daughter Louise. He died of pneumonia at age 91 on December 22, 1903.

Washington Corrington's grief-stricken family had barely walked

away from his grave when the *New York Times* on December 31 heralded the filing of his will in Peoria's probate court with the article: "For a New University Washington Corrington Leaves $750,000 To Found Educational Institution."

Grief became rage.

By the end of February 1904, after the disclosure of the amended 1897 will whereby the entire estate—save for funereal expenses—would fund a university, his children launched a protest against the validity of the will. They argued that their father was "in his dotage . . . and he had been in such a condition ten years prior." The children based their assault of their father's will upon a "philosophy of life" they felt he had developed.

At the jury trial, they deployed a "scorched casket" strategy involving their father's trusted personal physician, Dr. H.H. Whitten, who spoke eerily of his deceased patient. Corrington, the good doctor divulged, claimed that he had "discovered the source of Life and the Essence of Spirit in 'oxygen,' and that 'oxygen was God.' " The doctor continued, "during all of these years he would call attention to what seemed to me a glow or spark in the shrubbery about his home, and declare that there was 'Spirit.' "

That's what Washington Corrington's children wanted: The Prairie Moses and the Burning Shrub; all that was left was for the doctor to exclaim that his patient, had indeed parted the Illinois River, or at least made it shallower.

Leaving nothing to chance, the Corrington children unleashed a flanking argument that their addled father did not have a million dollars for a college; indeed, they valued his holdings at no more than $100,000.

It was, they said, just another example of his senility: grand fraud. But he wasn't so daft that he didn't allow for his own burial expenses of $225 rather than leave *that* decision to his family.

With Washington Corrington out of the picture, the jury agreed to set the will aside. The children would get their cash.

The trustees appealed, but, in November 1904, the Appellate Court upheld the judgment against higher education.

Of the 480 acres once owned by Washington Corrington, only a half-mile or so of an East Bluff residential street, known as Corrington Avenue, remains today. One part of Corrington's dream lives on, though: there isn't any college football playing in Peoria.

4. PASSIN' THROUGH

Slim and None

"What you've got for me, Peoria?"

These were the first words spoken by Charles "Slim" Lindbergh after landing in a squall at Peoria's Big Hollow Airport in the 1957 film *The Spirit of St. Louis.* The movie, in which Lindy is played by Jimmy Stewart, was possibly the first hint for many people that the famous aviator had any connection at all with Peoria.

History shows that there was in fact a close association, one that could have been world-famous had the city not missed its chance by the slimmest of margins.

In the last draw of sunset, Slim had just enough daylight to spot the home of Lee Hunt on Peoria's north side; he nosed the DeHaviland biplane toward earth to buzz the teen's house. When Lee heard the DH-4's thumping whir, he ran out the door, jumped on his bike, and pedaled fast toward the nearby Kellar Field that served as Peoria's airport.

Meanwhile, Slim cruised shallow and dragged the field before his descent onto the darkening airstrip that he guessed doubled as a cow pasture, which in fact it was in an earlier life, as part of the Brown family farm. But since April 15, 1926, Peoria was part of Contract Air Mail Route 2, and air strips had to be found where they could. The route also included stops in St. Louis (the headquarters of Robertson Aviation, the route licensee), Springfield, and Chicago.

On this evening Lindbergh, the chief pilot for Robertson, was running late on his return leg to Chicago because of another mechanical glitch in his World War I–vintage airplane.

On the ground, Lee hopped off his bike, ran to the supply shed, grabbed some flares, and raced to the runway where he lit and planted them. He stood by as the plane landed and waggled to a halt at the end of the strip. Slim curled the DeHaviland to midfield before cutting the engine; the pilot jumped out of the cockpit onto the wing and waited as the mail truck pulled up. With over an hour of flying still to go, Slim was all business tonight. He tossed a shriveled gunny sack to the mail handler, who in return threw just as light a mail bag to the pilot, who stuffed it in the plane before slipping back into the cockpit.

The pilot smiled at Lee, waved, and rattled away into the dusk, leaving Peoria's first airfield behind.

The season had changed to fall by the time the second airfield, located on State Highway 30 on the northwest side of Peoria, opened on September 30, 1926. The new and improved airport answered to Big Hollow, Varney Field, or simply Field Two, as the airport manager Alexander Varney called it; he had managed Kellar Field along with his flight school, which he brought with him to anchor the new one.

It was a heady time for the children at the Orange Prairie Grade School, a one-room schoolhouse named after a nearby Osage orange tree, located a quarter-mile from the Field Two hangar near the southeast edge of the airport—at the intersection of past and future. Warren Frye, an 11-year-old student at the school, lived just south of the school and airport on his family's turkey farm on U.S. Route 150. In fact, Warren's father Fred Smith Frye had owned the 160 acres that became Field Two. The young boy, already a fan of airplanes even before the rolling of the runways started, spent as much time as his father would allow him at the airfield and found in the 24-year-old Lindbergh a pilot who would actually talk with him about the nuts and bolts of planes and flight.

The former barnstormer probably saw a lot of himself in Warren, but their chats together in the whip of prairie winter winds would end in a few months when Slim had to say goodbye to his Field Two

greeter. And although he was just 11, Warren knew why: you never cut your engine when you're just lifting off.

Slim said so.

In his two autobiographies, *We* and *The Spirit of St. Louis*, Lindbergh said it was over Peoria, in late September 1926 on a return leg to Chicago (actually Maywood), that the idea to attempt a transatlantic flight from New York to Paris came to him. Immediately he began detailing the avionics of a solo flight; it was something he knew a thing or two about and it meshed well with his aptitude for logic, structure, and order.

The one aspect of the race for the $25,000 Raymond Orteig Prize for the first successful transatlantic solo flight that bothered him was the raising of funds; there were too many variables, which, for a scientific mind, can muddy even a perfect formula. Foremost, he had zero experience dealing with businessmen, especially in presenting a proposal with a price tag he estimated at $20,000. Lindy knew how to jaw with aviators, but the moneymen wore fancy suits, smoked big cigars, and talked funny; they were . . . different. And he didn't like different.

How did they think? Would they care a whit if the plane he envisioned hurtling over the Atlantic was basically a flying gas can? That his plan eliminated every conceivable nicety that could weigh down his plane? That only a certain engine—built *right*—would do? How would they feel if he left his toothbrush and toothpaste out of his carry-on kit?

Who knew? They were businessmen.

Then there was the age issue. Lindbergh was a "boyish-looking" 24 years old, which meant they would see him as inexperienced and immature, even though he was the chief pilot of the number-two air mail route in the United States.

Even if Lindy was lucky enough to answer all of his questions and find values for all the variables involved in the funding chase, who would he talk to? From the moment he conceived The Flight, he

knew his best chance was in St. Louis, where his bosses, the Robertson brothers, had one of the top aviation companies in the country. But what if he didn't anticipate the questions the St. Louis moneymen might feel were just as important as the impact of shear forces on wing integrity?

Given the preparation that Lindbergh took in his career—he even analyzed the risks he had taken as a barnstormer—he knew he'd have to practice his pitch. It didn't make sense to start at the top with his best chance, where failure meant the end of his dream. It did make sense to have a trial run and work out the kinks in his proposal and eliminate variables.

Also, as he wrote in *Spirit,* he really didn't know anyone in Chicago; the metropolis was too large and he could squander the valuable variable of time chasing down leads. Peoria was the right size city for him, prosperous but comfortable; it also had a strong aviation community and signaled its belief in the future of flight by the development of a new, bigger airport.

Lindbergh shared a bond with fellow barnstormer and Peoria airport manager Alexander Varney, who also ran one of the top flying schools in the nation. After involvement with the second airport project, the Delavan native would know exactly who in Peoria had the cold cash and an airy heart toward flying.

A pitch rejected by Peoria, while sad, wouldn't be as devastating as one from St. Louis. He'd learn a thing or two from the trial, lose his jitters, and still have his entire St. Louis network left.

If Peoria said yes, well, great.

The idea that Lindbergh went to Peoria first with his transatlantic proposal works even with the lack of a paper trail and the silence of the people involved. After all, Lindbergh, with his taciturn bent and ambitious pride, wouldn't reward a rebuff from Peorians by telling the world about it if he thought the failure might reflect poorly on him. And after his transatlantic triumph, would any businessman want it known he had turned his nose up at the chance to ride on Lindy's

coattails for universal prestige and fortune? Who would want everyone to know that they had lacked vision? And that they had denied their city of Peoria its chance to become a real hub of aviation?

To be fair, the business elite of Peoria had every reason to turn him down. It was a classic case of great idea, wrong guy. After all, Lindbergh, during a six-week stretch in the fall of 1926, was busy jumping out of airplanes. And the Peoria men must have known about his airmail-route crashes on September 16 and November 3 outside of town. If he couldn't fly between Peoria and Chicago without crashing, they could be excused for wondering, how could he possibly fly across the Atlantic without dunking himself—and their money—into the ocean? As if that wasn't enough, he had that barnstorming nickname, "Daredevil Lindy."

Beneath Lindbergh's shy demeanor was a cast-iron ego, an unforgiving memory, and a sullen silence over perceived slights. There was arguably at least one instance after the historic flight when Lindy partially snubbed Peoria. And vice-versa.

It happened when he embarked on his 1927–1928 Goodwill Tour sponsored by the Daniel Guggenheim Fund for the Promotion of Aeronautics. As detailed by Ev Cassagneres in *Ambassador of Air Travel: The Untold Story of Lindbergh's 1927–1928 Goodwill Tours*, Lindbergh "insisted on breathtaking precision and regularity and strict adherence to the schedule in order to prove the dependability and reliability of air travel." Without exception, Lindbergh stuck to his pre-established itinerary and visited 80 cities in three months; there wasn't one additional stop made.

Peoria wasn't on the list. It was the only city on Contract Air Mail Route 2 that he didn't visit.

However, on August 15, 1927, he flew a meandering route from Stop 21, Chicago, to Stop 22, Springfield, to Stop 23, St. Louis. Between Chicago and St. Louis, he flew over the Chicago suburbs of Mooseheart, Aurora, and Joliet before dragging Peoria's airfield two times and dropping a generic commemorative mailbag from

the *Spirit of St. Louis*. The city of Peoria didn't set a record for Lindy gifts either; Lindbergh's records showed he received medals from the Peoria chapters of the Daughters of the American Revolution and the Women's Christian Temperance Union. The city, like hundreds across the country, did name a public grade school after him. It also has a Lindbergh Drive near Mt. Hawley airport; it's one of the shortest streets in town.

Lindbergh never mentioned for the record whether or not he first tried to raise funds in Peoria for his historic flight. But the man knew how to keep a secret. In October 2003, DNA tests confirmed that the Lone Eagle had fathered three children with a German mistress; later came news that Lindy had four more children by two other German women who were sisters. Two of Lindbergh's mistresses were sisters who both had physical disabilities due to tuberculosis. The affairs started in 1957 and continued until 1974 when he died.

Though the women wrote him countless letters over the 17-year span, no one uncovered a shred from his voluminous collection of documents. It was as if that life never existed—though it did.

While the landing of Lindbergh's air mail plane on April 15, 1926, heralded the future of Peoria, the next day marked the passing of another era with the hanging—possibly twice—of Jose Ortiz, a Peruvian Indian convicted of murdering his girlfriend in a jealous rage on the downtown streets. His was the last hanging—or last two—in the city.

For decades a rumor persisted that Peoria County strung up the killer twice, because Ortiz may have suffered a fractured toe, as reported the following day in the *Peoria Transcript*, on his first hanging. Over time, others have insisted the injury was a broken leg. The second part of the speculation centered on whether the hangman repeated the hanging, or merely tightened the slack in the rope.

With few witnesses, a coroner who ignored the question of an injury and said only that Ortiz "died by strangulation," and Ortiz's

quick sweep into an unmarked grave, the answer will always remain vaporous.

But still, April 16, 1926, was a great day for a hanging in Illinois—it set a state record for the most in one day with five. Or six, if you believe the creaking from the gallows when the past followed the future in the air of Peoria.

Abe Stepped Here

Of the people who passed through Peoria on their way to greatness or fame, Abraham Lincoln was the one who transcended them all and became one of the greatest Americans ever. And Peoria was the place that launched him into history.

Abraham Lincoln first set foot in Peoria in mid-July 1832, walking from Wisconsin after a three month Army career during the Black Hawk War; along for the walk was a messmate, George W. Harrison. The two soldiers had planned to ride back to Illinois until someone stole their horses. For Lincoln, who mustered in as a captain but mustered out as a private, the stolen horse episode was yet another tale to tell. The rapid tumble in rank seemed like another amusing yarn, but the truth wasn't scandalous: he enlisted three times during his 90 days of military duty and his fellow soldiers elected him captain of their company in his first unit; thereafter, he accepted a private's pay.

The Peoria that Lincoln saw that summer day was a village of a hundred, if that. And most of the homes were frontier log cabins. A couple of stores provided basic goods, including a canoe that the two footsore soldiers bought. They paddled out of Peoria on the Illinois River to Havana, where they sold the canoe and parted company. Lincoln continued his walk home to New Salem; at the same time he was running for the Illinois House of Representatives. By August 6, he realized that he had mixed results in elections for the year: he won

his captain's rank by the vote of the men of his company, but lost the state house election.

Lincoln's next visit came on February 10, 1840, over seven and a half years later. By then, both the city and the man had grown. Peoria had a population nearing 1,500, or 15 times larger than 1832. Lincoln, a nobody from New Salem in 1832, was now a three-term state representative from Springfield on his way to a fourth straight win in 1840.

He was a leading Whig in Illinois and was in town to rally the faithful for General William H. Harrison, the Whig candidate for president. Harrison won and became the nation's first Whig president, only to die 31 days after his inauguration.

Lincoln would stump in Peoria six more times for Whig presidential candidates: four times in a losing cause in 1844 for another Kentuckian, Henry Clay; on October 9, 1848, for General Zachary Taylor, a Whig win; and on September 17, 1852, for General Winfield Scott, who lost.

Lincoln's last stump in Peoria for a presidential candidate was on October 9, 1856, for the anti-slavery Republican John C. Fremont; it was a loss for the newly-formed party.

Four years later and without campaigning in Peoria, Abraham Lincoln ran for president himself and became the first Republican to win the White House.

In 1834, the year of his first election as an Illinois state representative from New Salem, Abraham Lincoln began his law studies the old-fashioned way, by learning on his own. In 1837, after admission to the bar, he practiced law in Springfield and rode the eighth circuit of central Illinois that extended west to Tazewell and Woodford Counties in the Peoria area. Though he argued hundreds of cases in those counties, he tried only a handful in Peoria. During 1844, the year in which he spent the most time in town, in the May court term he assisted a couple of lawyers in a divorce case, Aquila Wren v. Clarissa (Jones) Wren. They lost. But the following October, Lincoln prevailed for Clarissa Wren when, after her ex-husband died in August, there was an error in his

will concerning a parcel of real estate that the ex-wife still held title to. At the same time, Lincoln won another judgment for a client, a New York manufacturer, against three defaulting Peoria merchants.

After a single term as a U.S. congressman in 1847–1849, Lincoln returned to his Springfield law practice and the circuit. He continued in law for the next five years, until the passage of the Kansas-Nebraska Act on May 31, 1854. The chief mastermind of the act was Illinois Senator Stephen A. Douglas.

The act effectively dissolved the 1820 Missouri Compromise and was enough of an outrage to Lincoln that it forced his return from the prairie wilderness back to the political jungle. Spurred by a letter signed by a number of Peorians, Abe jumped into the fray.

It happened one night in October in the city of Peoria in the year 1854. On October 16, Senator Douglas originally had planned a speech for a meeting of fellow democrats, but agreed to parry about the Kansas-Nebraska Act with Lincoln. The rules were simple enough: Senator Douglas would speak first and would have the last word after the attorney spoke; there would be no time limit on either man.

Around mid-afternoon on the courthouse steps that faced Adams Street, Douglas began a three-hour defense of the Act that basically boiled down to, "let the people decide." When the Little Giant finished testing the limits of the crowd's endurance, Abe suggested a chow break before his talk.

With their bellies full, the crowd listened for three more hours as Lincoln surgically dissected the notion that slavery could coexist with the very cornerstone of the Declaration of Independence—the belief that "all men are created equal." He gave full voice to his core beliefs and a preview of his destiny; that night in Peoria formed his anti-slavery manifesto—the abolitionist seed of all he'd say and write for the rest of his life.

Some quotes from his Peoria speech:

"I cannot but hate it. I hate it because of the monstrous injustice of slavery itself."

"Slavery is founded in the selfishness of man's nature—opposition to it, in his love of justice."

"No man is good enough to govern another man without that man's consent."

"Stand with anyone that stands right. Stand with him while he is right, and part with him when he goes wrong."

A Sunday Buffett

Sometimes when passing through Peoria, you end up with a smash hit. Singer Jimmy Buffett got a smash, and a hit.

Buffett played in Peoria for the last time on March 17, 1978, at the Bradley University Robertson Memorial Field House. With his flagship song "Margaritaville" beginning heavy rotation, small gigs would soon fade to black as he reached new levels of success and popularity. But for one more night, on a stage with a plastic palm tree as the only prop, he bid farewell to his River City past.

During the concert, Buffett told his fans about a previous show at Robertson several years before, "when the band was me and my guitar." That Peoria visit, he said, became the inspiration for his growing-up song, "Life Is Just a Tire Swing."

The songwriter said he had finished the gig at Bradley on a Friday night and drove to Macomb for a Saturday night concert at Western Illinois University. On Sunday he woke early and headed back to Peoria, and had a car crash that worked its way onto a song sheet.

The singer's crash outside Peoria recalls another, earlier passerby who survived two airplane crashes near River City and, oddly, became a celebrity less than one year later—Charles A. Lindbergh. Jimmy Buffett went on to his own style of stardom after his Peoria crash.

The Peoria lines come toward the end of "Life is Just a Tire Swing:"

> Then the other mornin' on
> Some Illinois road

I fell asleep at the wheel
But was quickly wakened up by a Ma Bell telephone pole
And a bunch of Grant Wood faces screamin' is he still alive?
Through the window I could see it hangin' from a tree
And I knew that I had survived

In Peoria, if you can make it out alive, you can make it anywhere—even if you're just passing through.

Vaudeville had it right all along.

The Center of a Doughnut Empire Goes Up in Smoke

In the early summer of 1937, as Peoria crawled out of the double whammy of Prohibition and the Great Depression, a young man from Kentucky drove into town with a dream: To go it alone and make the best *and* best-known doughnuts he could.

His dream worked out, but not for Peoria.

Vernon Rudolph had been in the family business—the doughnut business—since 1933, when he and his uncle, Ishmail Armstrong, discovered in Paducah, Kentucky, the extra-light doughnuts that a cook named Joseph G. LeBeouf occasionally made along with other treats aboard an Ohio River barge. It didn't take long for Vernon's uncle Ishmail to ask for the recipe (the secret: the amount of potatoes in the mix), which the pleased cook gave him and his nephew for their smiles alone. And soon the 18-year-old Vernon was making doughnuts at his uncle's general store and selling them wholesale to diners and restaurants. A year later the pair closed the store in Paducah and headed to the larger Nashville to open their first real doughnut shop, which they named the Krispy Kreme Doughnut Company. To convince him to leave home and friends, Uncle Ishmail first had to offer his foot-dragging nephew a half stake in the business within a year.

With little if any competition, the shop was an immediate, overwhelming success—so much so that after one year an exhausted Ishmail Armstrong offered full ownership to his 19-year-old nephew. When the youngster was unable to secure a loan, his father stepped in and bought the business. The father-son Nashville operation thrived over the next couple years and more of the family pitched in, expanding to Charleston, West Virginia, as well as Atlanta.

By 1937, twenty-two-year-old Vernon Rudolph's life-course seemed as set as the machinery that churned out all those doughnuts, until his Uncle Roy, who ran the West Virginia outlet, told him to break away from his father and go his own way; this time the young man didn't need much of a nudge. It wasn't long before he and a couple of his coworkers loaded a doughnut machine into a Pontiac and headed northwest.

Peoria was a day's ride from Nashville and a cut against the grain from the usual pattern of exodus at the time: from the South to Detroit. The Illinois town of 100,000 looked like Nashville at least, with its rolling hills and smokestacks. The downtown was dazzling. At 12:00, the noon whistles competed with train whistles for top noise. It was also a river town on a wide-open rebound; for someone willing to work hard and dream harder, the city was a siren's call. Yet as his car sputtered through the downtown traffic, something worried Vernon.

Too many doughnut shops.

They were everywhere—just like the taverns and gambling dens. It wasn't Nashville, where Krispy Kreme reigned alone. It was a letdown, since one failure could scuttle him; he needed a location where he could be sure his shop would survive long enough to make Krispy Kreme a national doughnut power.

Parking the Pontiac and walking around Peoria to mull his hard choices, Vernon opened a pack of Camels. For a second, he stared at the cigarette pack. The fact that he could light up a well-known, national-brand cigarette from Winston-Salem, North Carolina, right there in the middle of the country, stirred him: Why not there?

The Pontiac headed southeast, and no one glanced at the countryside.

Winston-Salem passed muster. Though not devoid of doughnuts, the town seemed a good fit to Vernon; he defied superstition by opening his own Krispy Kreme shop on Friday the thirteenth of July, 1937. The dynasty he started there became the rave of the country, and his dream was realized.

Peoria lost out to a smoke and cold feet.

There *was* competition in Winston-Salem when Vernon Rudolph started his shop. Joseph Lingle had already developed a prosperous doughnut and cookie store down the road from the Krispy Kreme. After a time, Lingle called on Vernon and offered him his doughnut customer list—as long as Vernon promised to treat his loyal base well, which the Kentuckian immediately agreed to do; Lingle wanted to concentrate on his cookies. That began a friendship that lasted until Vernon's death at age 58 in 1973.

This friendship also had a Peoria connection: Lingle had once owned one of those Peoria doughnut shops that Vernon may have seen and been unnerved by in the summer of 1937, though neither man knew this. Lingle had moved to Winston-Salem when he married a North Carolina girl.

And the cook, Joseph LeBoeuf, who had the original recipe that started it all? He went upriver from Paducah to Louisville and became a riverboat captain. The 93-year-old died in 1999 without knowing the part he played in the Krispy Kreme legacy; but, according to his daughter, he enjoyed Krispy Kreme and called them "the best doughnuts."

Vernon's dream had come true.

5. WHEN LAW AND ORDER DIDN'T PLAY IN PEORIA

Mayor Woodruff and the Friendly Crime Fines

When it came to audacity, Peoria's longest reigning mayor, Edward N. Woodruff, had few peers in city, state, or national politics. From his first election in 1903 until his last one in 1941, through 11 mostly nonconsecutive terms and 24 years in office, he was the town's ringmaster, guiding Roaring Peoria during Graft's Gilded Age.

Born February 8, 1862, the native Peorian was one of seven children of Nelson and Mary Woodruff. His father started an ice plant that stored blocks of ice harvested from the Illinois River; it was a successful business that Ed inherited until the advent of artificial ice. Woodruff Ice later merged with Peoria Service Company in 1929.

A friend to all, Ed Woodruff developed an interest in local politics in the late 1800s, and ran for alderman twice as a Republican, winning both times.

In 1903, Woodruff won his first mayoral contest and served two years. He was out of office until elected again in 1909, after which he went on a tear, winning six straight times and serving 12 years in a row until 1921—the Ballot Box Bambino's longest stretch in office. Mirroring the calls to break up the Yankees in their heyday, Woodruff lost in 1921. And again like the Bronx Bombers, he came back to win it all in 1923, but lost again in 1925 and 1927 to Louis Mueller. Woodruff then regained city hall in 1929 before losing in 1931 and 1933. Rebounding once more, he won in 1935 and 1941, with David McClugage beating him between terms. Woodruff's last hurrah was in 1945, a loss to reformer Carl Triebel.

Over the course of 19 Peoria mayoral elections over 42 years, he

went 11-8. Win or lose, Woodruff was the steadying rock, a familiar succor, in Peoria politics during the first half of the twentieth century: if there was an election, he was probably on the ballot. To many he was a "Little Napoleon" who would follow each triumph with a topple from power, only to climb back up, again and again and again. The ability to come back after defeat upon defeat was never seen as a sign that Woodruff, "Dearie" to his friends, was punch drunk, but rather that he had a resilient love of the game of politics.

Ed Woodruff was the ultimate liberal, holding a feather rein on Peoria and allowing it to run wide and wickedly open, as long as the operators of gambling halls and brothels knew to tip the city till. With the dirty money, known as the Madison Avenue Fund (city hall being on Madison), Woodruff operated a government that didn't rely on constantly heaping taxes on its citizens. Though a number of aldermen, policemen, and civil servants may have been on the take, no one ever accused Dearie of pocketing any illegal dole; he was a modest fellow. Aboard the Bum Boat (an abandoned and beached stern-wheeler he converted into a shabby cottage on the Illinois River near Rome, north of Peoria), old cronies of the mayor/ex-mayor plopped down—after loosening their ties, taking off their sweat-stained shirts, and letting their suspenders sag to the sides of their pants—for "friendly" card games, cigars, booze, and politics. It wasn't a place for anyone Woodruff called "porch climbers"—self-serving toadies who sought political office for their own financial gain.

Not that he was against patronage—he believed plenty in rewarding those who helped him. But that certainly didn't make Woodruff unique among the pols (in fact, it made him a pol): It was his bold fee schedule for the lawless and his impious public support of vice that set him apart from the rest. When he said, "You can make prostitution illegal, but you can't make it unpopular," it *played* in Peoria. And when, during a December meeting, a contentious city council that had authorized a crackdown on the red-light district had to listen as His Honor moaned that "such an action in the week before Christmas

would be unChristian," *that* played in Peoria, too.

When pushed to uphold the law against gambling, he groused, "What's next? Outlawing checkers?"

Believing that honesty with the dishonest was the best policy, Mayor Woodruff ensured that the gambling and prostitution elements of Peoria understood his fee schedule by posting it in public, including periodic tallies of the collected vice fees, by category, in the newspapers.

But though he tried, Dearie wasn't able to corral the gambling houses and bawdyhouses into well-confined districts. Indeed, many gaming joints were within chucking distance of city hall, so that there wasn't much excuse for missing payoff deadlines. That was a no-no with the Woodruff administration, and the main reason why the deadbeats lost city protection.

The 1941 monthly fines, trumpeted by the mayor, were clear and simple:

Slots (per machine)	$20
Roulette wheels	$250
Crap tables	$500
Horse racing bets	$500
Baseball pools	$2,000

Other games also had fees assessed. Thanks to the number of slot machines throughout the city, including those at the Main Street Steak 'N Shake, Peoria's coffers fattened from $138,000 during the 1935–1937 Woodruff regime to over $170,000 in slots alone during his last administration in 1941–1945, which coincided with Peoria's World War II military contracts at Caterpillar, R.G. LeTourneau, Keystone Steel & Wire, and other local plants. Also, with the end of prohibition, the town's distilleries and breweries experienced a rousing surge in demand. (Prohibition hardly dried Peoria anyway. One federal agent in the 1920s moaned that the city was "hopelessly wet.")

Fees for the over 80 brothels in town were highlighted less

dramatically, maybe out of a sense of decorum. Yet every Monday, flesh monies wended their way to the city treasury to help with "street sanitation."

Workers in the Peoria area had lots of money for play, making Woodruff's last mayoral turn a gratifying time.

For four years, from 1941 to 1945, old Ed Woodruff enjoyed a profitable and symbiotic relationship in the last act of his life with the Shelton Gang, recent imports from southern Illinois. But by the end of World War II, Peoria's mood soured. In the 1945 mayoral election Carl Triebel, a clean-'em-up candidate, bumboated Peoria's mayor by promising real reform to the voters. Speaking for an era lost, Dearie lamented, "The crusaders got me."

It was the end of honest, in-your-face corruption, and the finale for the friendly crime fines of Peoria. The town's greatest liberal died a couple years later in December, 1947; it was finally curtains for the Comeback Kid.

In something akin to naming a Chicago school Capone High, the city in 1939 dedicated Woodruff High School in Dearie's honor, and the Roarin' Peoria icon lives on and on.

The Shelton Gang: If We Did It, This is How We Did It

In the 1930s, word was the Chicago mob—shreds of the Capone gang—was looking toward Peoria as an obvious place to expand its crime base. To get a feel for the turf, they leaned on Clyde Garrison, a local gambling boss. Without muscle to push back, Garrison turned to the Shelton boys of southern Illinois: Carl, Roy, and Bernie, and offered them a stake in his gambling empire in exchange for protection. The brothers' reputation for butchery and throat-grabbing terrorism, earned through bloodbaths with other gangs and with the Ku Klux Klan in St. Louis, East St. Louis, Cairo, and "Bloody" Williamson County during the 1920s, was enough to keep the Windy City syndicate out of Peoria.

Garrison's invitation gave the Shelton Gang crime-world legitimacy in Peoria, but their arrival caused noticeable wincing among the city's vice brotherhood.

If Clyde ever had second thoughts about opening the coop to a pack of jackals, he had little choice after the Chicago mob tried to kidnap him in October, 1930, instead killing his wife and leaving him wounded in a gun battle outside his garage on North Linn Street. Besides, he was from southern Illinois, too. That had to count for something.

During the late 1930s, the partnership played for a while: Peoria sizzled with the end of Prohibition and its booze flowed over the world once more. Gambling tithings rolled into the pockets of Clyde and the Sheltons, and Clyde introduced his herd of dirty local politicians to soft-spoken smoothie Carl, whose hellfiend-tempered baby brother Bernie was in lockstep behind him.

Meanwhile the town's top politico, Ed Woodruff, the off-and-on mayor since 1903, had ungreased palms. Instead, on behalf of City Hall, the grafty mayor, with a face of deep shadows, shook down Carl and his league of gambling partners—a reversal of the traditional politico-criminal roles.

Boss Woodruff's payoffs, known as the Madison Avenue Fund since City Hall and the wagering house with its collection jar were across from each other on Madison, were a boon to both the city and the Sheltons: the city received enough dirty money to run the government without tax-bombing its citizens—many still in the shadows of the Great Depression—and the gang raked in higher profits thanks to lower overhead (less need for lawyers, smaller bribes, and fewer man-hours lost due to police shootings).

Another benefit for everyone was the relative peace on the street, enforced by the Shelton Gang. Jumpy Peorians knew better than to spit on the sidewalks without asking Carl Shelton's permission first, always worried that hair-trigger Bernie might be right around the corner.

By the end of the decade, Clyde Garrison no longer worried about the Chicago mob; his henchmen had seen to that. The Shelton Gang practically *dared* the upstate syndicate to cross them. But with the 1940s ahead, Clyde seemed an unnecessary part of what Carl Shelton began to see as *his* gambling empire, and a drag on the gang's bottom line. Besides, Carl no longer needed Garrison to peddle influence with City Hall; the politicians all understood that the affable guy with the pearl-handled pistol in his waistband was the town's real river pilot.

So Clyde retired without hitting the deck. Carl Shelton swatted him away from the lucrative business like flicking a flea off his fedora. And he didn't even have to spill any blood in his takeover of the largest city in the gang's history. Not that that would have stopped him.

The years 1940–1945 were a heyday for Peorians who, thanks to windfall World War II military contracts at local heavy machinery companies—Caterpillar Tractor, RG Tourneau, Wabco, and others— had real cash for the first time since Prohibition and the Great Depression. Every night was a party, and the prairie city never slept; that meant flush times too for gangsters and City Hall.

People spent their small fortunes at the gambling houses and saloons along major downtown streets. Shops and eateries offered slots and other games. And if there was any money left, the town had 80 brothels with bright red lights burning. It was the 1920s all over again, this time with legal hooch.

But the rest of it was illegal . . . and ignored. Mayor Woodruff looked the other way as long as his fines were paid, and the Shelton boys saw to it that the money continued to pass through their hands. The only confusion was who was feeding on whom. It was a high tide that lifted all boats, but for these shady symbiotes, it was the last one of their careers.

The end of Peoria's free-wheeling gangster era was signalled by Boss Woodruff's defeat by Carl Triebel in 1945. Fed up with years of corruption, Peorians elected Triebel, who seemed a crusader when compared to Dearie, with a mandate to clean up the city once and for all.

Carl Shelton realized he had to move quickly to protect his position with the new administration and sent an envoy, Ferd "Fishmouth" McGrath, to the mayor-elect for a courtesy call. Triebel refused the gang's deal and even went so far as to nix the whole notion of gambling, which left Fishmouth gaping. Practically before the mayor's door had closed, Carl Shelton was at Treibel's doorstep himself to set matters straight. But it wouldn't be business as usual in Peoria anymore. Instead of threats or even a "practice" shot over the mayor's head, the two spoke peacefully and Shelton realized that without a gambling empire to run, he'd have more time for family farming—a shared interest, it turned out, of both Carls—and the two went their separate ways amicably.

True to his word, Carl headed back south to Wayne County to farm, while Bernie took over the Peoria gang (though most believed Carl still called the shots behind the curtains). The churlish baby brother moved the gang's headquarters from the downtown Palace Club on South Madison to his Parkway Tavern on Farmington Road, just west of city limits; Peoria County offered more privacy . . . or so he thought.

Watchful eyes in the Chicago and St. Louis mobs saw that the Sheltons were on the ebb and Peoria was ripe for the taking. To hasten the process, the Chicago mob placed a $10,000 bounty on two of the brothers, Carl and Bernie.

Soon there was a pile-up of bodies at the morgue, starting with the unsolved February, 1946 murder of a Shelton associate, Frank Kraemer, owner of The Spot Tavern on Knoxville Road and a partner of the Par-K-Club on Hamilton Street. Kraemer died by gunshot in the comfort of his Farmington Road home; rumor has it that Carl Shelton himself ordered the hit after Kraemer returned from a meeting with rival thugs in St. Louis.

Then in September the police found Shelton muscleman Joel Nyberg shredded by bullets on a nearby Lacon golf course, case unsolved.

Weeks later, in another unsolved murder case, Phillip Stumpf, a

Shelton slots operator, was hit by shots fired from a .351 caliber rifle while driving along Big Hollow Road on Peoria's wooded northwest side.

Through all this, Carl and Bernie managed to stay off the slab. That changed the next year.

On the morning of October 23, 1947, Carl Shelton was driving his Jeep over a small bridge on Pond Creek Road near his brother Roy's farm when he was hit by gunfire from the brush nearby and fell out. Following him in a truck were his bodyguards Ray Walker and Little Earl (his nephew), both unarmed. At the first shots, the two jumped out of their truck for the cover of a ditch. From there they allegedly heard Carl cry out, "Don't shoot me anymore, Charlie. It's me, Carl Shelton. You've killed me already." A silence was followed by a hellstorm barrage of gunfire.

The "Charlie" in question was most likely former Shelton gang gunslinger "Black Charlie" Harris: a local hood who developed a loathing for the brothers when they didn't bring him back after his prison hitch. After the murder of Carl Shelton, a grand jury let Black Charlie walk despite the testimony of Little Earl and Ray Walker.

With the unsolved murder of his brother a sad burden, little-known Shelton brother Big Earl, who after spending years in prison was a non-player during the gang's Peoria years, penned a wailing, emotional song for him, "The Death of Carl Shelton." It was a hit on all the Shelton-controlled jukeboxes in Illinois—it had to be, or else.

Bernie had no time for mourning or music after the death of his brother. Pressure from the $10,000 bounty on his head meant plenty of sideway glances for someone who was used to ramming straight ahead. But under Bernie's glare, the gang's Peoria operations kept defying the outside outfits. The baby brother also kept greasing the palms of key officials in the tradition of his older brother Carl.

He also kept using his raw temper to full advantage to keep his staff in line, intimidate the average Joe, and discourage any pretenders to his throne. One rage took place at the Parkway Tavern on Memorial Day

1948, when Bernie and two of his thugs unloaded on a bar patron, hauling him to the parking lot where they would have more room to finish their pistol whipping of him. By June, the "Shelton Gang Three" were indicted for felonious assault with intent to kill.

But Bernie was a no-show for his August court date.

In the late morning of July 26, a lone gunman perched in the dense brush that topped the ravine outside the Parkway Tavern. As Bernie walked toward his car, a crack from a .351 caliber rifle startled the summer din of birdsong and insect rasping; Peoria's gangland era ended with a thud on the parking lot pavement.

The Shelton family buried Bernie at Parkview Cemetery—in the city of his first, and last, command.

Despite the rifle left behind on the brushy knoll, no arrests were ever made.

Bernie's death, while tragic to his family, instigated an upheaval in the 1948 elections. The two-term Republican governor, Dwight Green, had the cash support of the many gambling halls throughout the state and was a heavy favorite for re-election against an unknown Bloomington patrician, Adlai Stevenson. But, with Peoria in the spotlight following the hit on Bernie and the surfacing of a secret tape Bernie had made weeks before his death of an extortion attempt by a crony of Peoria's state's attorney, Republican Roy P. Hull (offering to drop the felony charges against him for a $25,000 payout), the GOP faced an electoral nightmare. Stevenson won, launching his career into national and international prominence. And certainly helped underdog President Harry Truman win reelection.

Charges against Hull were later dropped, based on the idea that the whole incident was a Shelton entrapment and an unauthorized shakedown by Roy Gatewood, who acted "without Hull's knowledge."

After Bernie's death, the Shelton gang fled Peoria for Wayne County and their hometown of Fairfield. Whether tracked by the big city mobs or not, life for the remaining Sheltons was a matter of hit-or-miss. From May, 1949 until early June, 1950, Big Earl and Little Earl

were the chief targets in a shooting gallery—nicked and spun, but not flattened.

Then, on the morning of June 7, 1950, while the oldest Shelton brother Roy, who also had little to do with the gang's time in Peoria, plowed a field on Big Earl's farm, gunshots from a bordering thicket sheared him clean off the tractor, killing him. The murders of the three Shelton brothers remain unsolved.

Roy was the last Shelton dropped by gunfire. Scarred, and perhaps scared, especially after the bombing of Big Earl's house in the late fall of 1950, Big Earl and Little Earl moved to Florida in 1951 along with their remaining family, leaving bloody Illinois behind.

Big Earl died peacefully in 1968 in Jacksonville. Little Earl, the bodyguard for his uncles, met a similarly non-violent end in late 1998.

In 1950, an article in *The Saturday Evening Post* named the Sheltons "America's Bloodiest Gang."

6. CRIME DIDN'T PLAY IN PEORIA

Wicked Wyatt

Before Wyatt Earp became a legendary lawman at Tombstone's OK Corral in 1881, he spent time on the dark side of the jail bars in 1872 Peoria for his toil in the local flesh trade.

Born in Monmouth, Illinois, on March 19, 1848, Wyatt seemed destined to land in nearby Peoria, though not until his early twenties. His frontier Midwest upbringing made him a young man with a mad streak of viciousness when riled, which at first helped him maintain order when he replaced his father, Nicholas, as the Constable of Lamar, Missouri, in 1870. It was also in Lamar that Wyatt married for the first time, but tragedy followed when his bride, Urilla, died a year later. Aimless in Lamar, he rode west.

By April, 1871, the former constable was on the run—accused of horse thieving in the western district of Arkansas Indian Country. Arrested and jailed April 6 with his alleged accomplices, Earp escaped a few weeks later in May, adding jail break to his growing criminal résumé. Though the Arkansas district issued an immediate arrest warrant for Wyatt, it went unserved because he was already long gone; the court later dropped the charges and cleaned the slate.

It was in the fall of 1871 that the Wyatt Earp story took a murky turn. Wyatt, a white hat fabulist in his later years, pitched the notion to his contemporary biographers that he went north to Kansas with Bat Masterson and spent the rest of 1871 and all of 1872 hunting buffalo before he went off to glory. But he wasn't in Kansas, and he wasn't hunting buffalo. In fact, he had headed east to the Bunker Hill red light district of downtown Peoria, joining his brother Morgan, a

barkeep, and trying his hand at pimping.

And for all Wyatt's crowing myth-making, there'd be that pesky Peoria police blotter.

By January 1872, he was in business with Morgan and a local who knew his way around the Peoria jail cells named George Randall; the three became partners with Jane Haspel, a madam who ran a popular bagnio (brothel) in the wide-open river town. Wyatt, unlike Morgan or Randall, moved into the Haspel joy house, which was on Washington Street near Hamilton, and went "hands on" to promote and protect his business. He was sure it would make him a fortune what with all those thriving saloons nearby, plus the railroads and the many ships docking daily.

But it was bad luck for Wyatt—just like in the Arkansas Territory the previous year—that Mayor Peter Brotherson and police captain Samuel Gill decided to bring the bagnio trade to its knees.

On February 24, 1872, the police raided the Haspel brothel and arrested Wyatt, his brother, and George Randall along with four women (including Wyatt's protégé, a young prostitute known as Sally Haspel, a.k.a. Sally Haskel, a.k.a. Sally Heckell, who on this occasion gave her "Name of the Evening" as Sarah Earp). The police charged Wyatt with "keeping and being found in a house of ill-fame." Found guilty, each man paid their fine of $22 plus court costs.

Two months later, on April 24, Minnie Randall—the prostitute who testified that Wyatt and his partners were at the Haspel whorehouse at the time of the February raid of their own free will, and not because of cold weather—committed suicide by taking morphine. Some say Wyatt and Sarah Earp were looking on. She died at the McClellan Institute, a joy house on Main Street near Water, a mere shot-glass throw from Jane Haspel's bagnio.

On May 9, the police rushed the McClellan Institute, nabbing no-luck Wyatt and his brother. Again found guilty of the "keeper" (pimp) charges, Wyatt and Morgan were unable to pay their fines, which had doubled to $44, so they served their time in the city jail.

The time worked wonders for Morgan: it was his last arrest in Peoria, and sometime during the early summer he left town—there would be no more Peoria Pimp Brothers showing up on the docket.

Wyatt, after his release, kept his name off the police sheet through the rest of spring and most of the summer, although in August, upriver on the Illinois in the town of Henry, the police detained him but brought no charges against him: He finally won one.

But this shock of good luck didn't last long.

By early September, Wyatt was working the flesh trade along the Illinois River on a floating cathouse called the *Beardstown Gunner*, named for a town south of Peoria; he seemed a diligent pimp.

On the evening of September 7, with the *Gunner* moored three miles south of the city limits so that Wyatt and John Walton, the boat's owner and a known Beardstown pimp, wouldn't have to deal with the Peoria police; however, the joy boat was still within the five-mile jurisdiction of Captain Gill and his men, and that night the lawmen climbed aboard the *Gunner*, arresting Wyatt, Walton, and Sarah Earp, along with five other men and four working girls.

A couple days later, on September 9, Wyatt garnered his third "keeper" conviction and a fine befitting a pimp of $43.15; it was his last conviction in Peoria. He may have been tough, but River City was tougher. Soon he left town with "Sarah Earp" and followed western sunsets to Dodge City, dreaming of fame. The OK Corral was another nine, dusty years away.

In Dodge City Wyatt took up the badge—if you can't beat 'em, join 'em—while Sarah stuck with tradition and started her very own brothel, protected by her man, and never jailed again.

For America, Wyatt Earp became its most famous lawman; for Peoria, he was a keeper.

From 1955 to 1961, ABC aired 266 episodes of the hit television series *Wyatt Earp*, starring Hugh O'Brian. Produced by Earp Enterprises, the series covered Wyatt's life after Peoria. The chorus of the theme

song, "The Legend of Wyatt Earp," written by Harold Adamson and Harry Warren, captured the scrubbed-clean tone of the show:

> Wyatt Earp, Wyatt Earp,
> Brave, courageous, and bold.
> Long live his fame and long live his glory
> And long may his story be told.

Nasty Nahas

John "Jack" Nahas sped into Peoria with high hopes in 1937 after a Midwestern crime tour that included his hometown of Indianapolis as well as Michigan City, Indiana; Miami, Ohio, where he owned a fleet of fishing boats; and Chicago. He'd heard Peoria was wide open, with lots of booze, betting, and babes.

It was just like Chicago, but smaller and *ripe.*

With the boodle he made from the sale of his Michigan City casino, Nahas and his wife Agnes, who went by Bonnie, bought Walt's Tavern on West Garden Street, and he looked around at the local possibilities. With a son, John—adopted in Michigan City in 1933 without Bonnie's name on the adoption papers—the Nahas family eased into the comfort of pre-war Peoria.

Yet the self-touted "chauffeur" to Chicago's Scarface Capone yearned for his own mob and a city under *his* thumb—That would be more like it.

Sure enough, his west-end tavern, through its gaming, brought in enough cash that Jack soon owned the downtown Slipper Club as well as a reputation as a player in Roarin' Peoria; at the same time he tapped a fellow Lebanese named Barney Radwin as his fist . . . his "Bernie Shelton." But unfortunately for Nahas, when it came to intimidation, no one confused Barney with Bernie unless they rattled off the name too fast. Nahas's boasts of once being Big Al's driver didn't help either,

resulting in more laughter than respect.

Rather than face the Sheltons head to head for the Peoria gambling empire, Nahas opted for pimping. His Slipper Club drew sinners like flies on last week's garbage, yet he had an iron-fisted rule against swearing inside the bar. Even Jack couldn't resist the temptation when he spotted a Peoria showgirl named Frida. With his wife Bonnie paralyzed from an earlier fall down some stairs, Nahas gracelessly divorced her and married Frida in 1944.

Nahas felt the need to branch out, so he bought the Plaza Hotel, which made sense, red light–wise. It also helped the accounting since City Hall, under the Woodruff administration, insisted on its share of the prostitution profits.

Meanwhile, the Shelton Gang watched Jack's vice world grow and felt the itch. But Jack, who had a temper to match the boys from southern Illinois, sneered at the first courtesy shakedown by smooth Carl Shelton, which meant a follow-up visit by Bernie and his thugs. Knowing this, he upped his security, using Barney as a human shield.

The beating meeting never happened, at least not in the traditional Shelton sense; maybe the gang gave up. Nahas could hope so, at least.

Eventually, after rubbernecking everywhere he went for a while, Nahas's jitters calmed along with his fear of the Sheltons. He let down his guard, just a little. It was almost enough.

In the early morning hours of July 9, 1945, Jack walked into a downtown bar and straight into an ambush. He took five slugs before he dropped, but somehow managed to keep breathing while his blood pooled on the barroom floor.

The doctors and nurses stopped the bleeding and saved the pimp, even if they couldn't remove all the bullets.

Weeks later when he left the hospital, Nahas vowed to himself: Barney's going first through every door from now on. He also vowed revenge, tagging Shelton bootlick Joel Nyberg as the trigger.

Fourteen months later, in September 1946, on a golf course in nearby Lacon, a groundskeeper found Nyberg's bullet-riddled and

Continued on page 97

This map shows the fossil River Teays and its tributaries around two million years ago, before it flowed into the ancient Mississippi just south of Peoria near present-day Lewistown. The resulting prehistoric "Super" Mississippi River, 900 feet deep in places, flowed south, emptying into the northern extension of the Gulf of Mexico near St. Louis. (Illustration by Hugh T. McGowan.)

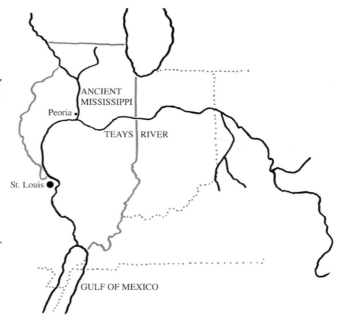

ANCIENT MISSISSIPPI

Peoria

TEAYS RIVER

St. Louis

GULF OF MEXICO

This picture taken near Peoria evokes a time when the original Mississippi coursed through what is now known as the Illinois Valley. One of the several nicknames of the Mississippi is Moon River. The Illinois River today generally follows the riverbed of the Old, Old Moon River. (Photo from the Jack Bradley Collection. Permission granted by the Peoria Historical Society Collection, Bradley University Library.)

Jean Pointe DuSable, a French-Haitian, was an early, prosperous Peoria settler who later founded Chicago. This statue of DuSable was created by Peoria artist Preston Jackson. (Courtesy of Karen Camper.)

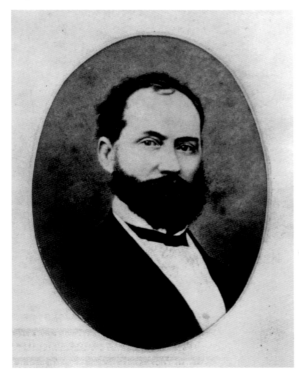

This photograph of Dr. Elias Samuel Cooper was taken c. 1855. Cooper founded Peoria's first hospital, The Peoria Eye Infirmary and Orthopedic Institute, in September 1851. He later founded the first medical school on the West Coast. (Permission and courtesy of the Lane Medical Library, Stanford University School of Medicine.)

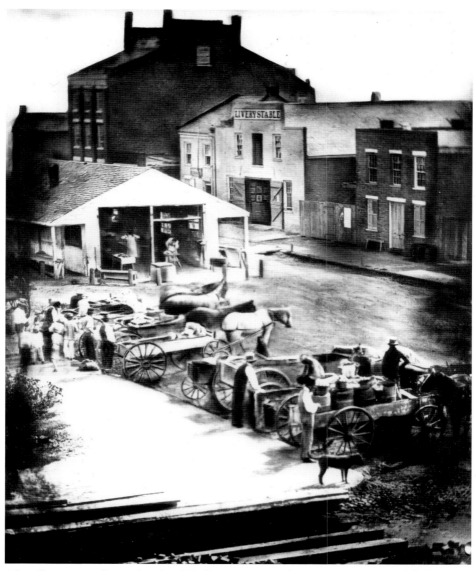

This illustration shows the City Market House—a downtown commercial hub on the 100 block of N.E. Washington St.—as it appeared during the decade that Dr. Elias Samuel Cooper wielded his knife in Peoria (between 1844 and 1854). (Photo courtesy of the Peoria Public Library.)

Old Tom helped secure the Illinois State Normal University for Bloomington during the bidding war with archrival Peoria in 1857. The unsung hero went the extra mile. (Illustration by Hugh T. McGowan.)

Washington Corrington's vision of a Corrington University in Peoria goes up in the flames of the "Burning Shrub" tale during the contesting of the farmer's will in probate court. (Illustration by Hugh T. McGowan).

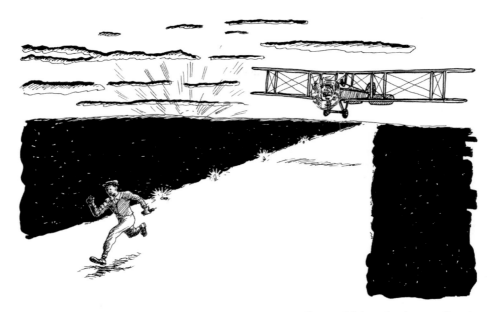

This illustration shows Lee Hunt lighting the way at Kellar Field for Charles Lindbergh. (Illustration by Hugh T. McGowan.)

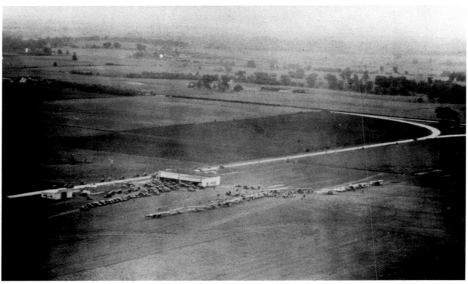

This aerial photograph shows Peoria's second airport, known as Big Hollow Airport, which opened in September 1926. Charles Lindbergh landed here many times during his last few months as an airmail pilot. Half a year later he would become an international legend. Warren Frye's school, Orange Prairie, is at the far right toward the middle. (Photo courtesy of Suzanne Frye.)

A shy Charles Lindbergh, chief pilot for Robertson Aviation Corporation of St. Louis, which operated a four-city airmail route, stands next to Phil Love, another Robertson pilot. The Peoria postmaster is shaking hands while ceremonially receiving the air mail for the first time on April 15, 1926. Peoria was one of four cities on the nation's second airmail route. (Photo courtesy of the Peoria Public Library.)

The "Line in the Sand" statue of Abraham Lincoln at the entrance of the Peoria County Courthouse commemorates his famous October 16, 1854, "Peoria Speech" that would be the nucleus of all his future speeches regarding slavery. (Photo courtesy of Karen Camper.)

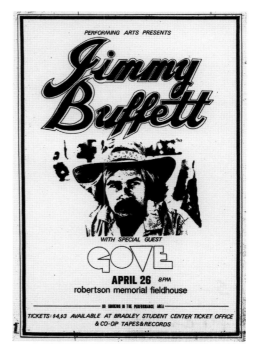

This poster promoted Jimmy Buffett's April 26, 1975, concert at the Robertson Memorial Fieldhouse. A couple of years earlier the singer had a car crash in rural Peoria County. That Peoria crash became the basis of his autobiographical song, "Life is Just a Tire Swing." (Poster courtesy of the artist, John McNally.)

Vernon Rudolph, the founder of Krispy Kreme Doughnut Company, at home in Winston Salem, North Carolina, around 1966. Rudolph had visited Peoria in 1937, looking to set up shop. (Photo courtesy of Carver Rudolph.)

This 1969 photograph shows Vernon Rudolph with his son Carver, when the family still owned Krispy Kreme. Beatrice Foods absorbed Krispy Kreme in the late 1970s. (Photo courtesy of Carver Rudolph.)

This is a very early image of Edward N. Woodruff, Peoria's "Mr. Mayor." Woodruff has the distinction of serving more terms than any other mayor. He also holds the record for the most losses by a mayoral candidate. Born in February 1862, he died in 1947. A lifelong Republican, Mayor Woodruff was crime's best friend. (Photo courtesy of the Peoria Public Library.)

Mayor Charles O'Brien turned over the reins of Peoria city government to wily old pro Edward Woodruff in 1935. Mayor Woodruff would stumble in the next election, losing to Dave McCluggage in 1937 for the first four-year term in Peoria's history. Yet in 1941 Little Napoleon would begin his last term and his first four-year term. (Photo courtesy of the Peoria Public Library.)

This billboard on North Main Street captures the essence of Woodruff, The Constant Campaigner. The date is unknown, but also shown in this picture is the entrance to one of Peoria's dance halls, the Inglaterra. The Methodist Hospital Atrium sits on this site today. (Photo courtesy of the Peoria Public Library.)

Mayor Woodruff called his political clubhouse the "Bum Boat," which was on his riverfront property at Rome, north of Peoria. (Illustration courtesy of Hugh T. McGowan.)

Bernie Shelton's Golden Rule house at the end of Shelton Lane. In mid-summer 1948 when Bernie was still breathing, the house was the scene of an alleged extortion by a proxy of Peoria State's Attorney Roy P. Hull to drop a felony assault against the gang chieftain for $25,000; Shelton secretly taped the shakedown. Bernie died and Hull skated. (Photo by Karen Camper.)

Peoria's first jail saw a lot of use in its day, but by the 1930s the city razed it. The structure had stood at 100 N.E. Perry Street. (Photo courtesy of the Peoria Public Library.)

In 1872, nine years before the Gunfight at the OK Corral, America's most famous lawman Wyatt Earp spent a notorious year in Peoria's red light district as a "keeper." After three arrests and jail time, a chastened Wyatt, scared straight by the Peoria Police, left town for Dodge City where his legend "officially" began. (Illustration by Tim McGowan.)

This 1940s photograph shows John "Jack" Nahas and his second wife Frida. Nahas was a notorious pimp from the time he arrived in Peoria in 1937 until his death in 1978 at age 82. At various times he owned Walt's Tavern, the Slipper Club, and the Plaza Hotel. (Photo courtesy of Peggy Leadley.)

This Charles Manson postcard mentions the serial killer's disdain for Peoria jail food. (Courtesy of Bloody Mess.)

East Peoria's Par-A-Dice gambling boat has spurred growth of the town. The boat's former anchor, Peoria, is in the background. (Photo by Karen Camper.)

The World War II ship museum USS LST-325 sits in the Mississippi River at Moline, Illinois. In 2005, Peoria was a contender for the ship's home port, but lost to an enthusiastic Evansville, Indiana. During the 1990s, the LST-325 served in the Greek navy as evidenced by the nameplate seen here.

This photograph shows Betty Friedan in 1960. Born in Peoria on February 4, 1921, Betty Goldstein became an ardent feminist leader who founded the National Organization of Women (NOW) in the 1960s. In 1963, the mother of three burst upon the writing scene with The Feminine Mystique. *(Photo courtesy of Library of Congress.)*

In his last years as a performer, Peorian Richard Pryor, crippled by Multiple Sclerosis, still found humor to share. He died in California on December 10, 2005, from a heart attack. (Photo courtesy of the Peoria Journal Star.*)*

Peoria's most famous agnostic, Robert G. Ingersoll, was born August 11, 1833 in Dresden, New York. He arrived in Peoria in 1857 after a short sojourn as a lawyer in Southern Illinois. After a brief Civil War career, Ingersoll returned to Peoria and his wife, Eva Amelia Parker of Groveland. Known as the greatest orator of the last half of the 19th century, he died in New York in 1899. (Photo courtesy of Library of Congress.)

Fulton J. Sheen, whose nickname was "Spike" in honor of his pompadour, was the Spalding Institute 1913 Class valedictorian. Ordained in the Peoria Diocese in 1919, the future Archbishop Sheen became the most famous Catholic in America by the 1950s because of his prolific writing and his weekly television series, Life is Worth Living. He died on December 9, 1979. (Photo courtesy of the Diocese of Rochester, New York Archives, and the Fulton J. Sheen Center, Peoria.)

This 1909 graduation photo of the eighth grade class at St. Mary's School in Peoria features the already brilliant Fulton J. Sheen, seated in the center of the front row, as its top student. (Photo courtesy of the Diocese of Rochester, New York Archives, and the Fulton J. Sheen Foundation, Peoria.)

St Patrick's Catholic Church was the first and only parish assignment of a young Father Fulton J. Sheen in 1926. In the Mid 1970s, Reverend Bill Kinison bought St. Patrick's and renamed it the Miracle Life Cathedral. His younger brother, Reverend Sam Kinison, was an occasional preacher. (Photo courtesy of Karen Camper).

When Sam Kinison was a few weeks old he and his family moved to the Peoria projects from Yakima, Washington, but he went to school in East Peoria. He became a Pentecostal minister and then a comedic legend from the 1980s until his death in 1992. The irreverent reverend's favorite place in Peoria was the East Peoria Steak 'N Shake. His older brother Bill's first job was working here. (Illustration by Hugh T. McGowan.)

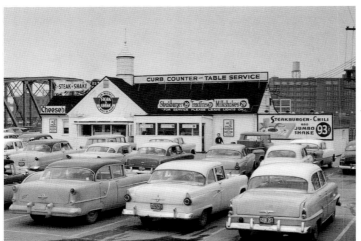

The old East Peoria Steak 'N Shake on the Illinois was Sam Kinison's favorite hangout in Peoria. Today, the East Peoria restaurant is the chain's second busiest. (Photo courtesy of Dan Bort and Steak 'N Shake, Inc.)

83

Former Red Sox owner Harry H. Frazee (second from right) joins the New York owners and Baseball Commissioner Judge Kennesaw Mountain Landis (second from left) in the Yankee dugout for the first game ever played at Yankee Stadium on April 18, 1923. (Photo courtesy of Library of Congress.)

In the latter half of the 1800s, the father of Harry Herbert Frazee owned the Peoria Pump Company. Its building at 600 Water Street is shown here. (Photo courtesy of Karen Camper.)

George "Lucky" Whiteman, 1918 World Series hero for the Boston Red Sox, was featured on the front of this c. 1908 postcard. The journeyman outfielder and native Peorian upstaged Babe Ruth in his last major league game.

This "goodbye cake" featuring a gorilla shaking question marks out of a tree was presented to the Peoria-bound Bette and Phil Farmer at a 1970 Hollywood farewell party. (Photo courtesy of Bette and Phil Farmer.)

NOV • 73 •

In 1974, science-fiction master writer Philip José Farmer posed as the fictional sci-fi writer/character Kilgore Trout, the alter ego of novelist Kurt Vonnegut. With Vonnegut's okay, Farmer wrote Venus on the Half-Shell *and published it under Trout's name. Then Vonnegut erupted; the spat ended in 2007 with Vonnegut's death. (Photo courtesy of Bette Farmer.)*

These photographs illustrate the beautiful views that led former President Theodore Roosevelt in 1910 to hail Peoria's Grand View Drive "the world's most beautiful drive." (Photos courtesy of Karen Camper.)

On Memorial Day 2007, General (ret.) Wayne A. Downing, "The Duke Without the Hollywood Swagger," delivered the keynote address at the Peoria County World War I and II Memorial dedication at the county courthouse. The speech was one of his last—the Peoria native and America's leading counterterrorism expert died less than two months later. (Photo courtesy of the Peoria Journal Star.*)*

Two days after September 11, 2001, a traffic stop in Peoria led to the arrest of an alleged al-Qaeda bagman, al-Marri. (Illustration by Hugh T. McGowan.)

This pre-deployment photo of the Army Reserve 724th Transportation Company was taken in the fall of 2003 at its Bartonville base. Unit members gather around the workhorse, an M9A71 fuel tanker with an M931 Tractor. While providing security for 19 civilian contractor fuel tankers on a run through the Sunni Triangle to Baghdad International Airport on April 9, 2004, the 724th was attacked in one of the largest insurgent ambushes of Operation Iraqi Freedom. (Photo courtesy of First Sergeant Chris Haines and Erin Plank, 724th Transportation Company.)

This photograph shows the windshield of one of the 724th Transportation Company's vehicles. (Photo courtesy of Dept. of the Army, Field Manual-1, June 2005.)

A Chinook of Company F of the Illinois Army National Guard out of Bartonville flies near one of Saddam Hussein's palace in Baghdad. (Photo courtesy of CW3 Jason Rassi.)

This is the unit patch of the "River City Hookers" Company F, 106th Aviation Battalion of the Illinois Army National Guard based in Bartonville. On November 2, 2003, insurgents hit one of Company F's Chinooks with a surface-to-air missile, killing 18 Soldiers, including 3 unit members, and injuring 25 more. At that point it was the worst single attack of Operation Iraqi Freedom. (Photo courtesy of CW3 Jason Rassi.)

This is the unit patch of Company C of the 6th Engineers, the Marine Corps Reserve unit of Peoria. (Photo courtesy of 1st Sgt. Casey A. Samborski.)

This television ad was for the fledgling 182nd Air National Guard unit in Peoria. (Photo courtesy of TSgt Todd A. Pendleton.)

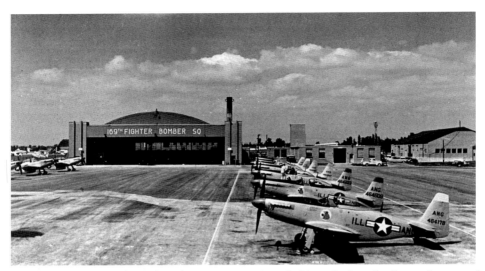

This row of F-51s belonged to the Peoria Air Guard. The 169th is the flying element of the 182nd Peoria Air National Guard. (Photo courtesy of TSgt. Todd A. Pendleton.)

This Peoria Air National Guard C-130E makes a historic touchdown on April 27, 2003. The plane was the first coalition aircraft to land at Baghdad International Airport. Onboard were members of the Iraqi interim government. (Photo courtesy of U.S. Air Force via LTC Steve Konie.)

The first airmen to land at Baghdad International Airport on April 27, 2003, were members of the 182nd Airlift Wing from Peoria. On board was a historic group: the first Iraqi Interim Government. The crew, from left to right, were: LTC George O'Bryan, SRA Dave Stone, MAJ Dean Meucci, LTC Steve Konie, MSG Matt Stone, MAJ Dennis Baker, A1C Jim Tillisch (USAF Raven), and TSG Ralph Prado (USAF Raven). The photograph was taken by CMS Rick Barnick. (Courtesy of Lt. Col. Dean Meucci.)

This photograph shows earthquake relief supplies being on-loaded to a Peoria Air Guard C-130. On December 28, 2003, a C-130 from the 182nd Airlift Wing and its Peoria crew entered Iranian airspace—the first American military aircraft to do so since the U.S. hostages left Iranian captivity almost 23 years before. The rapid humanitarian mission delivered 20,000 pounds of medical supplies in response to a deadly earthquake at Bam, Iran, on December 26. (Courtesy of TSgt Todd A. Pendleton.)

Afghanistan's President Hamid Karzai posed with his Peoria-based crew in April 2007 after a somber mission to the site of a mass grave from the 1980s. Pictured from left to right are: MSgt Lanny White, CMSgt Rick Barnick, Capt Jason Trevino, President Hamid Karzai, Capt Eric Dolan, SSgt Brian Layhew, and Capt Bruce Bennett. (Courtesy of Bruce Bennett.)

This Peoria Air Guard C-130 was photographed at Faizabad, Afghanistan, the site of 1980s Soviet atrocities, in April 2007. Note the Soviet steel planking runway. (Courtesy of Bruce Bennett.)

This "Play It Again Peoria" sign appeared on a wall of a downtown construction site for a proposed riverfront museum. (Photo courtesy of Karen Camper.)

bashed body. Whoever hit Nyberg hit him hard, not content with mere bullets. And though the motive for a Nahas-ordered payback seemed obvious enough, Nyberg had roughed up enough Peorians during his life of crime to make his murder unsolvable.

After the shooting, Peoria changed dramatically. First, the city came to grips with life after World War II. Second, the easy-going, greasy-palm days of Roarin' Peoria collapsed when Mayor Woodruff lost the 1945 election to reformer Carl Treibel. Peoria now enforced its laws and even made payoffs to politicians a *crime*.

The underworld sky had fallen on the river city.

Without help from City Hall, Nahas's overhead skyrocketed. He had to contend with police raids, bail and lawyers for his girls, and fines for saloon infractions and his other rackets. But the newly reformed Peoria had one positive for Jack: between 1946 and 1948, someone dropped three of the Shelton brothers, along with several of their henchmen, ending the gang's influence in the city.

Nahas tried to diversify by adding more joy houses to his flagship, the Plaza Hotel, yet the police kept raiding them as well. He also invested in legitimate apartments, 47 throughout the city, and brought his son John into the business as his rental manager in the 1960s.

But decades of police raids had a withering effect on Jack. In the early 1970s, perhaps nostalgic for the old days, a nettled Nahas bribed a vice squad policeman for "a little warning" before the next raid. Unfortunately for him, he tried to bribe an officer who despised him—and he knew it, too—but vanity overrode street smarts and Nahas gambled that he could get Officer Donald Short to take a bribe.

But a police tape caught the pimp's offer, and a jury found him guilty in 1972; the judge sentenced him to a term of one to five years in jail and a fine of $5,000.

He didn't serve a day. He wiggled out of the jail time on appeal, though he did pay the fine years later. However, he soon began a life sentence with Lou Gehrig's disease, which killed him in 1978 at the

age of 82. His passing mirrored the end of established whorehouses in Peoria. The city razed his Plaza Hotel to make way for the Bob Michel Bridge, and a different type of traffic.

"No-Name" Maddox, Food Critic
In March of 1949, a couple of teen runaways from Boys Town in Nebraska snuck into Peoria. They robbed a local food store twice and fled once. Twenty years later, one of them would become world-infamous as the mastermind of seven murders over two California nights in August 1969, slayings carried out by his "family."

The ragged journey began in Cincinnati on November 12, 1934, when unmarried 16-year-old Kathleen Maddox gave birth to a son. The baby went by "No Name" for several days until she decided upon Charles Milles Maddox. His last name changed to Manson a few weeks later when his mother married William Manson, who apparently wasn't the father.

Essentially abandoned by his hard-drinking, crime-loving mother, young Charles was in trouble most of the time. Frustrated Indiana authorities sent him to Boys Town, Nebraska, in 1949.

It didn't last long.

Within days the 14-year-old, along with kindred delinquent Blackie Nielson, broke loose, stole some wheels, and made his way to Peoria where Blackie's uncle lived. The uncle honed their thieving skills before sending them out for a big-boy job; one late winter night, the two robbed Waugh's Market on Southwest Adams Street. The teens hauled away $1,500; for their efforts, the uncle gave them a 10 percent cut—a payout of $150. Encouraged by the easy money, the boys wanted more.

On March 22, 1949, Manson and Nielson struck again, but this time when Charles ran out and hopped into the getaway car, it was a cruiser with two police officers waiting for him.

Manson's Peoria crime spree was over.

After the arrest—and after squealing on Blackie's uncle—the juvenile offender ended up at the Indiana School for Boys at Plainfield. From there it was one prison after another until the 1960s and California.

Years later, in 1990, a Peoria rock musician named Bloody Mess heard that, while in prison in California, the convicted murderer was making little scorpion statues, so he wrote and asked Manson if any of his art was for sale. Manson replied by postcard on November 20, 1990.

The text, in which Manson mentions his time in Peoria and offers his opinion of the merits of the city's jailhouse food, reads as follows:

> All of that stuff is put out for a fast buck. The albums are poor & the books are bogus bunkum.
>
> I don't buy & sell things. I'm not in the trade. I guess if I were to sell one all the others would lose their power—scorpions have a power, the way they are put & the way it came in to real.
>
> If I were to sell one, 5 million but I don't sell them. No I don't write that much. I ran out of things to say long ago.
>
> I lived in Peoria, Il. in the 1940's. I robbed my first store there. Wahas [Waugh's] market. 150 bucks big deal for a kid. The jail there had bad food.

So No-Name Maddox says great-tasting jailhouse food doesn't play in Peoria. With a lifetime of experience, he should know.

Hinckley's Hick Town

On March 30, 1981, John Hinckley Jr. shot and wounded President Ronald Reagan and three others, including the president's press secretary James Brady, who suffered a crippling injury.

Sent to a Washington, D.C. psychiatric hospital after his conviction by reason of insanity, he spent hours reading music reviews. In 1985 he saw a reference to a magazine published by Peoria rocker Bloody Mess and asked for a sample copy.

Later, Hinckley sent a thank-you note to Bloody Mess in which he casually dismisses Peoria as a place worthy of anyone's time, let alone home, when he asks Bloody what he's doing there. This from the wannabe presidential assassin writing from his psychiatric confines. The failed assassin, who had never been to Peoria, unfortunately illustrated the extent of the city's blighted image in his offhand slight.

The text reads:

> Dear B.M.—I enjoyed your mag. I'd like to hear your band so send the cassette. What the hell are you doing in Peoria of all places? J. Hinckley

7. "THOSE" SHIPS AREN'T WELCOME IN PEORIA

Par-A-Dice Lost

For a river city with a rich, colorful, and varied past, Peoria hasn't drawn scores of visitors interested in seeing the oldest continuous settlement of colonial America's near frontier. The underwhelming tourist trade is one of several reasons why the state's "Second City" has stumbled to number six in population in Illinois during the first years of the twenty-first century.

Many cities the size of Peoria yet without Peoria's colorful past have vibrant economies founded on tourism. Part of the problem is that Peoria's spectacular river vistas have gone largely unnoticed, with only a few major community events to draw attention to what brought people here in the first place. Unlike Naperville, Illinois, and San Antonio, Texas, both of which have put a lot of lipstick on their lesser riverfronts with great success, it seems the river—and the past—just doesn't play in Peoria.

Once upon a time the river brought plenty of people to town, and Peoria profited greatly from illegal gambling, thanks to the vision of Mayor Ed "Dearie" Woodruff. His crime fund kept the city afloat with so much dirty money it didn't need to crack the backs of its citizenry with taxes; the town was a red-hot sin city, a blue-collar Vegas.

Later, with gambling legalized in Illinois, a sanitized spirit of Dearie returned in the form of the Par-A-Dice riverboat casino that docked at downtown Peoria's riverfront and sent tax dollars to City Hall. For a while, it was like old times all over again.

Until something odd happened: a Peoria mayor, Jim Maloof, bemoaned the presence of *gambling* in his town and led a righteous

campaign against the riverboat; the only thing stranger would be for a Las Vegas mayor to rail against casinos. Meanwhile, attracting less attention but of far more substance, a legal wrangle concerning state gambling licenses was underway. With the help of former governor Big Jim Thompson, an East Peoria group happily welcomed the Par-A-Dice to their side of the river and offered a generous buyout of the casino owners and a concession that half of their taxes would return to Peoria.

Peoria traded 100 percent of tax revenues from gaming for 50 percent, but at least City Hall had the satisfaction of seeing "that sin-boat" to the other side of the Murray Baker Bridge—so near, yet . . . so near.

The phrase "Will it Play in Peoria?" gives the river city universal recognition that most other cities only wish they had. But Peoria has yet to embrace the slogan as anything positive. With more "play" in future development, a world of good is possible.

Build a Dock, and They Will Come

Even though wartime Peoria of the 1940s was in full roar, riverfront crowds watched as the newly-launched transports known as "Landing Ship, Tank," or LSTs, steamed down the Illinois from the upstream Seneca Prairie Shipyards on their way to the Mississippi and on to New Orleans. In all, 157 LSTs went past Peoria from the end of 1942 to June of 1945. From the mouth of the Mississippi, the transport ships made their way to beaches under fire in the Solomons, Italy, Saipan, the Philippines, Iwo Jima, Normandy . . . almost any shore touched by World War II. These naval workhorses hauled tanks, jeeps, bulldozers, and troops to enemy coastlines and helped shorten the war.

Some 60 years later, Peoria essentially stood silent once again in the presence of an LST. This time the city lost its chance to be the home port of a unique, working World War II ship museum, the LST-325.

In the spring of 1940, some 340,000 allied troops were cornered by the German army at Dunkirk, France, and strafed by the Luftwaffe. Their rescue, from May 26 to June 4, known as the Dunkirk Evacuation, relied on small fishing boats, barges, and pleasure craft in addition to British warships. The near-disaster convinced Great Britain's prime minister Winston Churchill of the need for large transport ships that could handle ocean travel and still be able to beach themselves to land (or pick up) men and equipment.

The British Admiralty brainstormed with the U.S. Navy in November 1941 and within days, John C. Niedermair of the American Bureau of Ships came up with a design that solved the problem of conflicting requirements for blue water travel and beach landing with a water ballast system inspired by his previous work with submarines.

The Navy awarded LST contracts to inland shipyards, chiefly Evansville, Indiana; Jeffersonville, Indiana; Pittsburgh, Pennsylvania; and Seneca, Illinois. These yards and others launched over a thousand of the 328-foot transports during the war.

Launched at Philadelphia on October 27, 1942, the USS LST-325 first saw action in the Mediterranean and later on D-Day as part of Force B, the backup for the first Allied invasion group that landed at Omaha Beach on June 7, 1944.

The ship served for 20 more years until it was decommissioned and sold to the Greek navy in 1964 and renamed *Syros*, L-144. The Greek navy decommissioned the ship at the end of 1999 with the intention of scrapping it.

However, in 2000, USS LST Ship Memorial Inc. bought the old LST from the Greeks and, with a crew of mostly World War II veteran sailors, sailed the ship 6,500 miles from Crete to a shipyard in Mobile, Alabama.

For the next five years, the association paid a daily docking fee of $155 to Mobile, which stretched thin the organization's budget. In need of financial relief and a permanent home port, Captain Bob Jornlin, commanding officer of the LST-325 Ship Memorial, in 2005

sent inquiry letters to the mayors of 19 U.S. cities that had navigable river frontage; he received a response from three of them. Two of the cities, both in southern Indiana, had a history with LSTs: Jeffersonville (across the Ohio River from Louisville, Kentucky) and Evansville, also on the Ohio. The third river city was Peoria.

Evansville erupted with LST-mania. "From the mayor all the way to waitresses," Captain Jornlin recalled. The city's enthusiasm never waned, even after it received the 325's wish list, which asked for free docking, free utilities, a free museum/gift shop/office building, and discounted hotel rates for out-of-town staff.

Jeffersonville also saw the tourism potential of tapping into its World War II past and reacted with civic enthusiasm only a decibel lower than its bigger Hoosier brother downstream on the Ohio.

But Peoria played its hand with a poker face. On the LST's first pass, the mayor denied receiving an inquiry letter even though the captain had clearly sent one. When city officials met with Captain Jornlin, one of them sniffed, "ship museums aren't money-makers."

Jornlin countered that the 325 would be the only World War II ship within 500 miles of Peoria, except for the submarine at Chicago's Museum of Science and Industry, which was a huge attraction. The captain also pointed out that the LST would be the only working World War II ship museum in America, going from city to city.

Not giving up, the official charged that "Peoria doesn't have a history with 'those' ships."

The captain had to point out that Peorians had a history of watching "those" ships pass by the city 157 times on their way to war.

The Peorian shrugged, and remained silent.

Yet Peoria didn't reject the LST outright, thanks to the efforts of the business community led by Bud Ruff, an ex-Navy man. With Ruff's help, the city earmarked a suitable two-story building on Waters Street next to a Hooters restaurant as a possible site. The other items on the 325's wish list remained a "we'll see."

In the end, Peoria offered a tentative, conditional "definite maybe,"

focusing on the projected high costs of dredging and mooring, which, for a ship with a draft of less than four feet and designed for beaching, seemed dubious.

Evansville, meanwhile, etched everything in stone. And after years of "ifs" and promises by Mobile to make a permanent site, the LST organization had to love a town where everyone jumped through flaming hoops for the ship and tendered a firm, locked-down agreement. The city used money from the local casino to pay for a new dock for the LST.

At the end of August 2007, the USS LST-325 finally tied up at the Peoria waterfront just north of the I-74 bridge. The seasoned warhorse drew over 37,000 visitors during its two-week visit to the town—an average of 3,000 per day, which broke the ship's previous record at other ports of 2,500 per day.

A Peoria *Journal Star* front page story on September 6 about the successful visit quoted Peoria Park District supervisor of riverfront events, Bill Roeder, as saying, "It sounds like it was a great benefit to the community in business as well as tourists to the riverfront."

If you build a dock, it turns out, they will come.

8. They Didn't Stay in Peoria. . . But One Came Back

The Illinois Valley Girl and the Peoria Pyre

They were worlds apart even in Peoria. Betty Friedan, born February 4, 1921, the oldest of three children of Harry and Miriam Goldstein, grew up in the middle-class West Bluff on Farmington Road overlooking Laura Bradley Park. To the east some 19 years later, Richard Pryor, born December 1, 1940, spent his childhood at the edge of a downtown that caterwauled below the Bluffs.

Her intact family supplied fodder for her writing, especially the way her mother—a Bradley Polytechnic Institute grad who wrote a society column for a local paper before she dutifully retired when she married—sometimes sighed around the house. And Betty watched it all; she later exhumed the memories for her treatise *The Feminine Mystique*.

At the counterpole, Richard's fractured family meant a boyhood in overdrive at his grandmother's house where, for her clutch of working girls, anyone with greenbacks had entry. Behind closed doors, a corps of misfits schooled the youngster in Streets 101.

Both were products of the Peoria public schools, but with records that were direct opposites. Goldstein, encouraged by her parents, was one of six valedictorians in the class of 1938 at Peoria High School. Pryor, swayed by the night people, clocked out of Peoria High after hitting a teacher. Years later, Goldstein—as Friedan—and Pryor would win world-wide acclaim and honors for their writing in completely different arenas.

By the early 1960s, both Peorians were on-deck to fame: Goldstein had graduated *summa cum laude* from Smith College in 1942, worked as a writer for two radical union publications for a decade, married

theater producer Carl Friedman in 1947 (dropping the "m" later), and had three children while writing freelance.

Meanwhile, Pryor, after dropping out of high school in 1955, worked for a moment at hometown Caterpillar, dabbled in some other odd jobs, joined the Army from 1958 to1960, performed in amateur shows during a posting in Germany before being discharged for knifing a fellow soldier, and returned to Peoria, developing a comedy routine at Harold's Club before working stages in small clubs around the Midwest from 1960 to 1963 —the Chitlin Circuit.

Friedan's *Feminine Mystique* was released in 1963, and with it, the Women's Movement. Friedan, now in New York, gave voice to the "problem without a name"—the unfulfilling life of the homemaker and the nagging question: Is this all there is?

That same year Pryor left Peoria, also for New York, where he settled in Greenwich Village, a place founded as an artist colony by Peorian sculptor Fritz Treibel in the late 1800s. Between America's two top black comedians of the moment, Bill Cosby and Dick Gregory, Pryor formatted his skits more along the lines of the sunny Cosby than the satiric Gregory; he spent the next couple years inching up the Big Apple's stand-up ladder.

Friedan's transcendent three-year ride reached its peak in 1966 when the National Organization of Women—which she helped found— named her its first president; for all purposes, she was the fount of the women's movement. Though she would remain a feminist force for the rest of her life, 1966 would always be her moment.

Meanwhile Pryor moved through the clubs to his big break—*The Ed Sullivan Show*. From there, more network shows and bigger live gigs followed. Years later, in a 1978 interview with *Jet* magazine, Pryor said he went back to Peoria after his *Sullivan* appearance, hoping for acceptance from his hometown, but found only "friends" with palms itching for his new cash.

In 1967, Pryor walked out on a full house at the Las Vegas Aladdin Hotel, muttering, "What the f--- am I doing here?" He went

underground to Berkeley, California, to hang out with the movers and shakers in the Black Movement; in an interview with Henry Allen published in the September 5, 1978 *Washington Post*, he said, "Between '65 to '68, I had a metamorphosis. I found out who I wanted to be. And who I wanted to be was the same guy who used to rap on the street corner back on North Washington Boulevard in Peoria."

In the early 1970s Pryor re-emerged, this time with Peoria in tow, and he changed the comedy world. The first "real" Pryor album, *That Nigger's Crazy*, won a Grammy in 1974; he would win Grammies the next two years, too. A brace of Grammies in 1981 and 1982 followed, proving you *can* go home again.

Pryor became a five-star Hollywood franchise, making his mark in movies, television, records, standup, and writing. Dick Gregory, the early 1960s comedy star eclipsed by Pryor, said it best about the edgy upstart's crossover appeal: "He took the black experience and made it into a human experience." He also said, "Everyone has a Peoria in their lifetime."

Both Friedan and Pryor acknowledged the irrevocable imprint of Peoria on them, though Friedan was more ashamed of that part of her life. In an article she wrote for the November 24, 1978 *Minneapolis Tribune*, she wrote, "It used to embarrass me even to admit that I came from Peoria. It was a vaudeville joke, the epitome of a hick town." Pryor was less blunt, but more pointed, in a 1990s interview with Peoria *Journal Star* writer Phil Luciano: when asked if he had "any message to the folks in Peoria," Pryor assumed the voice from the movie *The Amityville Horror* and rasped, "Get OUT!"

While Friedan downplayed the city of her birth, she wasn't above using it to demonstrate—with aplomb—her own sense of the acclaim she had earned: "I guess I am the most famous person that came out of Peoria," she said in a 1999 interview with the Peoria *Journal Star*.

If Friedan was ashamed of Peoria, Pryor embraced it, using his time there to create fiery sketches about its street life that kicked in the world's stage door.

His life from the start yielded plenty of scratch for his routines, along with horrific physical consequences. He admitted in a 1978 *Jet* interview that his reinless wolfing of drugs, booze, and women stemmed from the fact that he "had a lot of guilt about being successful. Life doesn't change when you start making money; you have the same problems you've always had."

Pryor's upbringing was a recipe for deviancy: living in a string of brothels along Washington Street run by his grandmother, his father pimping out his mother, and becoming a victim of sexual assaults at age six by a neighborhood boy and a priest while he attended a Catholic grade school.

Despite their differences, Friedan and Pryor had some similar Peoria experiences; each remembered searching for true companionship. Pryor had to deal with the loss of his childhood as he rocketed toward a too-early adulthood, surrounded by adults and crime. Friedan felt a bias because she was Jewish in a Peoria she described as more a "Southern city than a Midwestern one"—a provincial town that valued conformity and distrusted "outsiders." She realized where she stood when a high school sorority wouldn't accept her, even though her longtime girlfriends were already sisters. The Peoria Country Club likewise denied membership to her family, despite her father owning the successful Goldstein Jewelry Company (which Betty later called the "Tiffany's of Peoria").

Both had their first stage moments in Peoria: Friedan won an award for her role as a madwoman in a high school production of *Jane Eyre*, while preteen Pryor wowed the audience as the king in the Carver Community Center's *Rumpelstiltskin*.

And both saw New York's Greenwich Village as a jump-off point for their post-Peoria lives—Friedan as a left-wing journalist and Pryor as a comic sketch artist.

Later in life, Friedan admitted that her Peoria roots had shaped her. She died on her 86th birthday, February 4, 2006, the visionary from Peoria who happened to change American society.

For Pryor, Peoria was never far from his lips; it helped him bend the course of comedy his way. And because he looked homeward, he hoped to see the town smile back at him. Most of the time, though, the town leaders looked away, choosing self-righteousness over compassion for a fellow Peorian, who, despite his own failings, fought through a wretched childhood and earned success. It didn't matter how many world-famous comedians revered his genius, or how many awards he earned, the lack of warmth in his hometown hurt him.

But after a couple of failed tries over 16 years, the Peoria City Council, in October of 2001, by the narrowest margin possible, proclaimed a stowed-away southside stretch of seven blocks of Sheridan Road as Richard Pryor Place.

After enduring nearly two decades of enfeebling multiple sclerosis, Richard Pryor suffered a fatal heart attack on December 10, 2005, in California. He had just turned 65.

Colonel Ingersoll and Archbishop Sheen

That two of the most highly-regarded orators of the nineteenth and twentieth centuries lived in Peoria during their formative years rather than New York, Chicago, or some other large city showed that the American Dream was possible in small towns. And it can come from the Heartland, even if it doesn't play in Peoria for long.

Along with his older brother and law partner Ebon Clarke, 25-year-old Robert C. Ingersoll wandered into Peoria in 1857 to set up a law office after several years of servitude in several southern Illinois practices, the last one being in Shawneetown. The brothers were keeping alive the legacy of their Congregational/Presbyterian minister father, Reverend John Ingersoll, of leaving town a step before a mob formed; the preacher had agitated numerous flocks throughout New York, Ohio, Kentucky, and Illinois with his abolitionist fire decades before the Civil War. Ebon and Robert held the same beliefs, which

were contrary to most southern Illinoisans; Robert also added highly flammable agnosticism to the mix, with predictable results among the God-fearing, pro-slave townsfolk of the time.

The Ingersolls never hammered their stakes deep.

However, in the late 1850s, with Peoria active in the Underground Railroad movement and many abolitionists around, the Ingersoll boys had found themselves a home. It didn't hurt that Peoria was a hub for a number of railroads that often required the services of a sharp legal mind with an even sharper tongue. And the brothers already had ties with several Peoria businesses from their Shawneetown practice. They also plunged into Illinois Valley politics as loyal Democrats, though they ignored the pro-slaver bias of Illinois Senator Stephen Douglas while campaigning for his successful re-election against Lincoln in the 1858 race.

In 1860, Robert, after two full years in the city, ran as a Democrat for the fourth congressional seat and lost, as did Douglas, who was the Northern Democrat candidate for president against Lincoln. Ebon showed more of a flair for elected office than his brother, winning three times and serving as a member of the U.S. Congress from 1864 to 1871.

When the Civil War broke out, Ingersoll saw a chance to fight for his anti-slavery faith. He formed the 11th Illinois Regiment Cavalry, which went into service on December 20, 1861, and took command as a colonel. Prior to the unit's February 22, 1862 departure to Benton Barracks, Missouri, the new colonel married Eva Amelia Parker—a freethinking humanist herself—of nearby Groveland, on February 13.

Under Major General Ulysses S. Grant's Army of West Tennessee, Ingersoll led the 11th into the Battle of Shiloh on April 6–7, 1862, and Corinth, on October 3–4, 1862. On December 18, the Confederate forces of General Nathan Bedford Forrest captured Ingersoll and 148 of his men near Lexington, Tennessee; the colonel was a prisoner of war for several long days until paroled by the custom of *parole d'honneur*, whereby prisoners of war won their freedom if they swore an oath not

to fight again. Legend has it that General Forrest, believing the men guarding Ingersoll were under the spell of the stump talker, said he'd trade the colonel for an Army mule. Regardless, the general released him, ending a fighting career of less than a year.

Repatriated to Peoria, Ingersoll soon denounced the Democratic Party as slavers, joined the Party of Lincoln, and became a leading Union jingoist. And outside of President Lincoln, he was a most favored orator.

In 1867, Illinois governor Richard J. Oglesby tapped the born-again Republican as the last appointed Illinois attorney general, a position he held until 1869 when he returned to Peoria. Though he continued to practice law, handling a number of high-profile railroad cases, the public wanted his voice and he spent much of the next eight years on lecture tours across the country.

Peoria nurtured Ingersoll with a diversity of viewpoints that reflected opinions throughout America; he polished his thoughts on an array of topics, including tweaks at religion. Outside of tub-thumping at political rallies, he was developing a winsome, logical style that would pack the halls and thwart his critics.

In 1870, he lent bluster to the women's suffrage movement at a Peoria convention where Susan B. Anthony was the main speaker; he remained an advocate until he died.

In his later Peoria years, Ingersoll eased into his persona as the Great Infidel, promoting secular leadership over theocratic rule. His last full year in town, 1876, eclipsed all of his public seasons, before and after. It started in June with the "Plumed Knight" speech, nominating James G. Blaine of Maine as the Republican candidate for president at the Cincinnati national convention; though his man lost to Rutherford B. Hayes, Ingersoll's oration set a very high bar for future political addresses; he became an instant icon. According to lore, Franklin D. Roosevelt, who knew how to gin a phrase, nicked parts of Ingersoll's Knight speech for his 1924 "Happy Warrior" speech nominating Alfred E. Smith for president at the Democratic National Convention.

On the Fourth of July, 1876, Ingersoll added more luster to his glory when he delivered his stirring "Centennial Oration" in Peoria, in which he said that the United States became the first secular nation on earth from the first sentence of the Constitution, "We the people," which he said meant that the government was not claiming derived power from God.

Because of overwhelming demand, he phased out his lectures in Peoria and visited city after city while riding the rails. In the fall of 1877 and after 20 years of fine-tuning, he left the city for Washington, D.C., where he could keep a closer eye on the government and practice law with his brother, who had retired as a congressman in 1871 but stayed on until his death in 1879.

Ingersoll enjoyed soaring fame in his post-Peoria years, at a time when public speaking was at its height as a spectator sport. With sold-out gates a certainty, promoters charged ungodly amounts for tickets—a dollar or more for most venues—to hear the good-natured, cross-choking crusader rail, without notes, for three or more hours about the sins of churches; hell-breathing, xenophobic gods; the value of living life *now*; the virtues of equal rights for everyone; and, if time permitted, a bit of Shakespeare. He even engaged in free-tongued firefights if religious men were present, which always made great theater. During his 1884 lecture "Orthodoxy," he said, "The clergy know that I know that they know that they do not know."

Earlier, in 1882, he had offered a creed of his own, "Happiness is the only good:"

> The time to be happy is now.
> The place to be happy is here.
> The way to be happy is to make others so.

His last move was to New York City in 1885, where he continued living the good life before succumbing to heart disease on July 22, 1899. It was a testament to his personal charm that both friends and

critics mourned his passing, except perhaps for one vocal minister who said, "Well, now he knows."

Peter John Sheen's birth on May 8, 1895, above the family hardware store on dusty Front Street in El Paso, Illinois, was a long way from anywhere, even in Illinois. His parents, Newton and Delta, were devout Roman Catholics and if they had any wishes for their first-born son, they might have involved priesthood.

He would be an obedient son.

In 1900, after his hardware store burned, Newton Sheen moved his family 30 miles west to Peoria, where his older brother Dan, an eminent lawyer and politician, would pay Peter's tuition at St. Mary's Cathedral School. Though later eclipsed by his nephew, Dan was the Sheen with early fame: a one-time law partner of Robert Ingersoll, 1908 Prohibition Party gubernatorial candidate for Illinois (and in the same year contender for that party's presidential nomination), inventor with a patent in 1900 for a propelling mechanism for boats, and author of a 1919 book about Fort Crevecoeur.

While at St. Mary's, from 1901–1909, Peter started down the path toward priesthood as an altar boy at age eight. Around the same time, he began using his mother's maiden name instead of his given name, as a nod of respect to his maternal grandfather. It caught on.

"Fulton" John Sheen went to Spalding Institute, a high school where he continued his hard work and academic supremacy, graduating valedictorian in the class of 1913. Yet it was his sunny disposition that made him a hit with his classmates and teachers. It was a preview of the future for "Spike" Sheen, who had picked up the nickname at Spalding thanks to his pompadour.

For his parents as well as for himself, he went to St. Viator's College in Bourbonnais in east central Illinois and earned his bachelor's degree in 1916 and a master's in 1917. Peoria Bishop Edmund Dunne then sent him to St. Paul's Seminary in Minnesota for the last step to priesthood. On Saturday, September 20, 1919, at St. Mary's Cathedral

with his parents looking on from the pews, his ordination into the Peoria Diocese took place—a fulfillment of a family dream.

Recognized for years within the diocese as an academic prodigy, Father Fulton J. Sheen received his first assignment: keep going.

With Bishop Dunne's blessing, he headed to Catholic University of America in Washington, D.C., for doctoral studies in Philosophy. After two years into a three-year program, in September of 1921, the university sent him to the University of Louvain in Belgium, one of the world's top Catholic universities. Father Sheen accepted his Ph.D. from there in 1923. The faculty invited him to continue his studies toward the rarified "super doctorate," the *agrege en Philosophie*.

After a year at the Angelicum in Rome studying theology, the University of Louvain bestowed upon him a post-doctorate with Very Highest Distinction, along with the Cardinal Mercier Prize for International Philosophy—both firsts for an American.

Europe genuflected before the priest from Peoria. Even for those trained to resist temptation, this was heady stuff.

Offers from both sides of the Atlantic poured in for the Peoria prodigy, with the most beguiling ones from Oxford and Columbia Universities; the enviable quandary caused him to write to his bishop for guidance. Bishop Dunne's answer was direct: Come home.

The Appian Way was a long way from Peoria's St. Patrick's Church where, during Lent of 1926, Father Sheen began his stint as an assistant pastor to Father Cullerton. The church at the corner of unpaved Saratoga and McBean Streets had been in decline for years. And though he may have yearned for academic halls, Sheen did his duty with zest, brains, and charm. Before long, everyone knew that Father Spike was home and the Diocese's forgotten church became pew-packed once more.

After nine months, the bishop told his scholar-priest that he had passed the test of loyalty with grace and humility; he then released Father Sheen to academia, to become an instructor in theology, philosophy, and religion at Catholic University.

It was the end of his only parish posting and the close of his life in Peoria.

By the late 1920s, Americans discovered what Europeans had seen a decade before: Fulton J. Sheen had an uncommonly gifted flair for oratory along with a brilliant mind. He was also a renaissance man with unbridled energy. Along with his teaching duties at Catholic University, where he'd stay until 1950, he wrote books and articles, maintained a dizzying lecture schedule, debated on secular issues such as communism and fascism, and dabbled in local radio.

His breakout move came in 1930 when he became host of *The Catholic Hour*, a weekly national radio program. Over the next 22 years he would expand his audience of the faithful to over four million, all caught by his engaging charisma and voice.

From radio Fulton Sheen, a bishop as of 1951, moved on to television. His show *Life is Worth Living* debuted in February, 1952, on the DuMont Television Network. The program featured the bishop alone in a study without any props or embellishments except a blackboard. Given the half-hour show's time slot on Tuesday nights opposite Milton Berle on NBC and Frank Sinatra on CBS, it seemed another St. Patrick's, a slum post no one else wanted.

Yet against all television logic the bishop electrified the nation, talking about topics that were broad in appeal and steeped in an easy delivery worthy of Olivier at his best. He leavened his homilies with well-timed bits of humor that perhaps came from growing up in Peoria, a city with more than its share of witty people. The Bishop's easy, natural humor played very well against the hammy Uncle Miltie; he won an Emmy as Television's Most Outstanding Personality for 1952 over many established entertainment icons.

Because millions of households, both Catholic and non-Catholic, watched *Life is Worth Living* over its six-year run, the New York Diocese auxiliary bishop became the most famous Catholic in the country. His message was to stand tall against sin and evil and he brought calm to a 1950s America rattled by the specter of the Red Menace unleashing

a nuclear night. In a segment from early March, 1953, which later became eerie, he thundered that Stalin would have to meet his fate; the next week the Soviet leader collapsed and died. To stanch the media frenzy, the bishop denied over and over that he had a crystal ball or a mustached voodoo doll.

He tackled a range of themes including psychotherapy, Darwinism, and the like, that showed the breadth of his interests. A recurring mantra, which was a homage to his Peoria upbringing, was his cry against rampant self-indulgence by those who wanted their salvation "without a cross" and a "Christ without his nails." With deep voice and furrowed brow, he warned there could be "no Easter without a Good Friday."

During Sheen's 1950s heyday, the number of converts to the Catholic Church skyrocketed. And during his time as national director of the American Society for the Propagation of Faith from 1950 to 1966, donations poured in and swamped the Church's coffers. The archbishop, as the magazine covers suggested, could do no wrong.

Yet in April 1957, the popular show ended and Bishop Sheen resumed his duties as New York's auxiliary prelate, but with less greasepaint. This worked for a while until the Vietnam War spawned its own segment on the nightly news and the once stiff-necked anti-communist cleric bellowed an early voice of protest against the fighting.

It was 1966 and soon he lost his directorship of the Society for the Propagation of Faith, but then won a one-way ticket to a town with far fewer microphones: Rochester, New York. He remained its bishop until 1969, when he retired a year short of an obligatory gold watch—testimony to a clash with his parishioners.

Also in 1969, Pope Paul VI proclaimed Sheen the archbishop to the Titular See of Newport (Wales). In this capacity he kept writing, speaking, and ministering for the last decade of his life. His diminished public visibility matched his ailing health.

On October 3, 1979, during a papal visit to New York, Pope John Paul II hugged the ailing archbishop at St. Patrick's Cathedral and

said, "You have written and spoken well of the Lord Jesus, and you are a loyal son of the Church." A couple months later, on December 9, 1979, Bishop Fulton J. Sheen died at his New York home at the age of 84.

Almost 23 years after his death, on September 14, 2002, the intensive process for the canonization of Archbishop Sheen for sainthood began. As of early 2008, Peoria, Sheen's home diocese and the place of his ordination into the priesthood, concluded its phase of the review of the archbishop's life and works with a mass on February 3 at the Cathedral of St. Mary. The diocese then sent its files to the Vatican for an exhaustive examination of the deeds of Fulton Sheen.

Peoria, like the rich land around it, provided Robert Ingersoll and Fulton Sheen with fertile ground to explore the diversity of American thought and culture; no opinion seemed too radical or, worse, too common to have throat in the town. Both men learned the art of debate in Peoria, along with tolerance for other views, strong work ethics, and a sense of humor that would disarm the nation.

Apart from their time in Peoria there were several ties between the two theologically-opposed personalities, but the one direct one was that Ingersoll once employed Sheen's uncle, Daniel R. Sheen, in his law office in the early 1870s. At the end, the two cast off their Peoria training wheels for the world; their last years were in New York, where they both died of heart attacks.

Sam Kinison

Great comedians aren't born that way; most prey on their past. Sam Kinison prayed.

He came into the world screaming. But, at the time of Samuel Burl Kinison Jr.'s birth in Yakima, Washington, on December 8, 1953, it wasn't shocking. That would come later. At the time, the real shaker

in the family was the father, the Pentecostal Reverend Sam Kinison Sr. himself. In less than a month after Sam's birth, a church leader booted Reverend Kinison from the pulpit, in front of the congregation, for preaching the heresy that his congregants must not follow the example of the apostles napping at the Garden of Gethsemane.

The next day, after a car ride with church men wearing fedoras and black overcoats, Reverend Kinison hurried his family to Peoria, the mother Marie's hometown—without a word then or ever about "the chat."

At the start of 1954, the Kinison family had moved into Warner Homes, the Peoria projects north of downtown along Upper Peoria Lake, where they lived for five years while the Reverend converted a Camp Street laundromat into a parsonage next to the East Peoria Community Church where he preached. During the Warner years, there were two major family events: they had a fourth son, Kevin; and while five-year-old Sam played in the street, a truck hit him. Apparently he was never the same after the accident. According to his older brother Bill, he became "ornery."

Ministers "rotate" their churches, and it wasn't long before Reverend Kinison towed his family to the Crusade Temple at 250 Washington Street, where they set up housekeeping in the basement. Sam attended the East Peoria Central Grade School across the street.

In 1966, when Sam was 12, his parents divorced. The court divvied up the boys, making Sam and Kevin, the youngest, stay with their mother, while Richard and Bill went to Peoria with their father, who had become a city bus driver. The young Sam, who adored his father, clashed with his mother, even—incredibly—losing to her in a shouting match. Out of frustration, he would often steal from her, including the church money. In time his bitterness faded, replaced by a lasting devotion to her.

But that didn't mean that he danced happily in the hills overlooking Upper Peoria Lake; Sam's early teenage years were so rowdy that it was obvious he would enter East Peoria High through the front door and

keep going straight out the back door. Hoping to avoid the inevitable dropout, Marie Kinison had Sam, on the eve of his sophomore year in 1968, join his brother Bill at the Pinecrest Bible College in Utica, New York. It would be the end of his central Illinois years.

At age 16, Sam dropped out of school anyway and went on the lam; he kept in contact only with his father, who in turn told the rest of the family that Sam was "safe" or "okay." It wasn't until he heard about his traveling evangelist Kinison Brothers, Rich and Bill, that he came out of hiding and rejoined his family, which was now split between Tulsa, where his mother lived, and Decatur, where his father was preaching again.

Then it was 1972. In early March Reverend Kinison died while traveling back to Illinois after a church conference in Ohio; he was 62. On the night before the funeral, Sam told his brothers that as his father's namesake, he felt the Call. Soon after, the 18-year-old joined his traveling evangelist brothers. What he lacked in theology he made up for with an intuitive stage presence. And he learned he could be funny.

He married his first wife, 19-year-old Gail, in Fairborn, Ohio, after singing with her in a choir at a church where he ministered; it was 1975. Unfortunately Sam had mistakenly idealized her sweetness and innocence; later events would prove him wrong. By 1977 Sam and his brother Bill were in Chicago trying a different type of preaching, "Bibling for Bucks," and it was an eye-popper for the sons of a Pentecostal parson. First, there was a service every night of the week. Second, they had to compete to keep preaching, much like an open-mic night or reality TV show. But instead of casting votes, the faithful chose their favorite preacher with cold cash.

Still, it was one of the few churches where a preacher without a flock could sermonize. Unfortunately for Sam, it was also hundreds of miles from his wife, who lied and cheated on him. When he uncovered the deceit during the holiday season, he disappeared again, resurfacing a few days later in Peoria to talk to Bill. He

concluded that he had lost his Call, saying "divorce doesn't look good on a spiritual resume." When prodded by Bill to find another way, his first thought was comedy; a number of his homilies brought chuckles from the pews and a stir of excitement within him. Sam decided that July 1, 1978, would be the day he said his last "amen" from the pulpit. At age 25 and after six years as a preacher, he walked away from the family trade.

He didn't know it then, but he'd already lived one of his routines: after two years of marriage, as he would later say, "Hell would be Club Med."

During his last circuit in 1978, he preached for a time at Bill's new church in Peoria, the Miracle Life Cathedral; it was the old St. Patrick's Church where Bishop Fulton J. Sheen first served as a priest. Bill's offer to the Peoria Diocese of $50,000 actually trumped a bid that was double his: a $100,000 offer by the Morningside Baptist Church, a black congregation that was once the church of Richard Pryor.

Sam also spent time in Houston, where he sermonized and womanized. One of his Texas women, Terry, showed him an ad for a comedy school at the Comedy Annex; he rushed in and never stopped.

After two years as the *Dallas Morning News* "Funniest Man in Texas" and having Rodney Dangerfield tell him he was funny, Sam headed to Los Angeles in the summer of 1980 to become a doorman at the Comedy Store, a job he kept for the next five years while his comic career simmered at five minutes a shot during Monday Open Stage, or "Animal Nights," at the Store.

By 1985 Sam was in his seventh year as a comedian and, though acknowledged as an original wit, his hell-raising, scatologic routines froze mainstream agents, leaving him open to the real possibility of ending up a never-been who never had a chance at a big break.

Then it happened. Rodney Dangerfield convinced Sam to appear on his HBO special *Young Comedians*, by assuring him it wasn't going

to be just an Animal Night on tape. To make room for him, the show had to bounce another comic, some guy named Tim Allen.

In six brief minutes on August 3, 1985, Sam expunged a lifetime of bullwhipping himself for being the slum son of a preacher and a failure. The seven-years-in-the-making "overnight" phenom was a thunderburst upon the comedy scene; showbiz folks were now clawing over each other to book him, even with his blue tongue. His network debut came a couple months later on November 14, on *Late Night with David Letterman*.

In 1986, he had his first movie role in Dangerfield's *Back to School* and released his first album, *Louder Than Hell*. His concerts were sellouts, and no longer confined to Mondays. He quit his "day" job as doorman at the Comedy Store. In October, his brother Bill quit the ministry after 17 years and became Sam's manager.

For the next four years, Sam's career blazed with freebasing sketches on women and marriage, biblical figures and the hypocrisy of organized religion, and other rages. But it was also a time when he turned against himself with uncollared frenzy, in the Hollywood style of booze and drugs. In May of 1988, Sam's younger brother Kevin, who also had been a preacher before joining the Kinison showbiz cadre, committed suicide in Tulsa at their mother's home; it cut a deep, black cleft in Sam's heart. He felt guilty because he had dragged Kevin into the business; the following summer, his stepfather died.

Meanwhile, the show went on. Sam became the first comedian to sell out New York City's Madison Square Garden. The next day, 82,000 fans packed the Meadowlands Stadium in New Jersey; it would be the largest audience of his career.

November marked the first and last time he played at the Peoria Civic Center, which he sold out. The highlight of his return, besides the triple steakburger binges at the East Peoria Steak 'N Shake, was the "lost weekend" bender with his boyhood idol, local TV weatherman Rollie Keith.

Sam entered the 1990s roaring and maintained a hectic concert schedule, all sell-outs. In 1991, he sought to increase his network time by becoming a bigger part of "family entertainment." He also added political commentary and Desert Storm bits to his routines. And for the first time, he took baby steps to clean up his personal mess of drugs and liquor.

But the decade would turn out to be much too short. After marrying his longtime girlfriend Malika on April 5, Sam died five days later on a desert highway after a head-on collision with a pickup truck driven by a drunk teen. He was 38.

His last word: "Why?"

The Peoria preacher/comedian was a tough one to peg. So original that even his millions of fans didn't understand why they loved him so much. Sam himself gave the best clue in an interview with Joe Dalton in a September, 1986 *Rolling Stone*: "I'm an average middle-class white guy that comes home from the job and sits there wondering why things are the way they are. I'm a product of middle-class mediocrity, and I want to get people through it."

After all, he did grow up in the classic home of Middle America. And being the son of a preacher added another dimension of grounding that often clashed with life's absurdities. Bill Kinison called his brother "The comedian for white guys" who gave loud voice to the angry and disgusted and made their ennui funny. Robin Williams, in a *GQ* magazine interview in 1986, connected the dots, Peoria-to-Peoria, when he said Sam was a "white Richard Pryor."

But while ranting against a world full of folly, he never skewered Peoria, a place he enjoyed as a kid, or his mother, whom he adored unconditionally. His grave is next to his mother, stepfather, and Kevin in Tulsa. Across the street, beyond the cemetery, now looms the familiar sign of a Steak 'N Shake, Sam's all-time favorite hangout.

Harry the Horrible and the Birth of the Curse

For America, January 5, 1920, meant 11 days left before last call. The country would go dry at midnight on January 16 with the dawning of Prohibition.

For Peoria, the date meant a crushing descent from the heights it had known as the Whiskey Capital of the World, when it was Uncle Sam's single largest source of tax money.

For Boston Red Sox fans, it was a day of shock and anger: *He* had sold the Babe. "He" was Harry Herbert Frazee, owner of the Red Sox. And the buyers were the middling New York Yankees, who, in their 20 years in the American League, had enjoyed early ends to their seasons without playoff cares. All that was about to change, and all because of Harry the Horrible of Peoria.

Frazee was used to calling the shots, as he had all his life. Born in Peoria in 1881, by the time he was 17 he was managing the Peoria Distillers, a semi-pro team that he also played third base for. Though his parents hoped he would join the family business— the Peoria Pump Company—he had developed an interest in the theater. But the young man's eyes weren't dazzled by the limelight; Frazee focused instead on the sure-fire cash behind the scenes. A natural hustler, he moved quickly from bellhop at a local theater to its assistant business manager, to advance agent for its road plays. While still in his teens, the Peorian demanded more than a salary to hawk the playhouse's next production: he wanted a slice of the profits. The owners, who thought the current show was a dud, agreed, thinking they'd made a bargain. That "bomb" made it all the way to San Francisco and put $14,000 in Harry Frazee's pocket and hunger in his heart.

At age 20, he wasn't working for a salary anymore; he preferred the thrill of the gamble as a producer and the jackpot profits when he won. He left Peoria for the cash cow of Chicago, where, besides building the Cort Theater in 1907, he produced enough winners to

enable him to take on Broadway. Hefty-headed, squat, and frenzied, Harry always kept the bottle on a short leash as he hustled his way to New York riches. It was home, only bigger.

Before long he enjoyed fame among the famous and produced even bigger hits, mostly fluff comedies. With partner G.M. Anderson he built the Longacre Theater in 1913 on what would later become Times Square, but lost it through foreclosure in the fall of 1914. Despite that rare setback, he stayed on the black side of the ledger with his knack for turning flops into hits and milking as much cash as possible from every production, usually by taking them on the road like in his Peoria days.

Flush with cash and restless, Frazee looked to major league baseball for a new project. At age 36, along with Anderson and another partner, Hugh Ward, he bought the reigning World Series champion Boston Red Sox, the most successful franchise in the land, for $675,000. The deal gave Frazee bragging rights among the Manhattan fat cats who followed the hapless Yankees; it was also a long way up from the Peoria Distillers.

But Frazee wasn't the only one who liked to call the shots. His purchase of the Red Sox upset the American League police state ruled by Bancroft "Ban" Johnson, the league's founder and czar, who liked to decide for himself who could and could not play ball in his league.

Iron-fist Johnson and tight-fist Frazee would clash many times over the next six years.

In 1917, the first season after Frazee's purchase, the Red Sox finished second to the Chicago White Sox, who went on to win the World Series. Boston's star was the kid pitcher George "Babe" Ruth, who won a career-best 24 games. World War I shortened the next season, but the Red Sox claimed their fifth World Series championship—more than any other team in the major leagues—thanks mostly to Ruth, who did double-duty pitching and playing the outfield.

The real hero for the Red Sox in the 1918 World Series wasn't the Babe, but a 35-year-old journeyman outfielder from Peoria named

George "Lucky" Whiteman. Even though he batted a middling .250 in the series, his hits had magic, leading to Boston wins.

But Lucky really shined in the outfield with game-saving catches; the most remarkable was his game-saving, series-winning somersault catch in the 8th inning of game six that kept the Cubs from scoring. The Catch was the last one of Whiteman's career: he severely wrecked his neck and left the game forever. The Fenway crowd roared out his name with cheers as he left the field. And his replacement, the Babe, went unnoticed—a rarity for the Prima Bam-donna.

It was Frazee's first championship, and it would be Boston's last in the 20th century.

The team skidded to sixth place in 1919 as off-field tension built between Frazee and his diva pitchers, Ruth and Carl Mays. It started with Mays, who blamed his losing record on his shiftless teammates. Disgusted, he vowed never to pitch for the Red Sox again. Johnson, the league's jackbooted despot, charged in and suspended Mays, meanwhile ordering Frazee not to trade him. Though he nodded, the Boston owner immediately offered the jumper to the other league teams, but received a cold "no" from most of them. Five, in fact. That's when it hit him: Johnson had touched them; they were his "Loyal Five."

Frazee had no option but to peddle Mays to the Yankees for $50,000. Johnson, in a rage, demanded the Yankees shelve Mays or forfeit any game he pitched. The Yankees owners slapped an injunction on the league president and his decrees. And it worked—Johnson backed down. But all of this was just a warm-up. The mother of all trades loomed.

In his first four years in the majors, Ruth was an outstanding hurler, leading Boston to two World Series championships while setting postseason pitching records. The Babe then defied baseball tradition by becoming an overnight slugging success in 1917–1918. His stardom forced Frazee to reluctantly dig deeper into his pockets and give Ruth a sizable salary hike to $10,000 a year.

Ruth wasted no time spending the money. He lived large and made great copy for the press. Frazee, the showman, lived by the creed that

money talks and stars must listen; it couldn't last.

As reporters and fans winked at Ruth's off-field antics, his teammates winced; they had to listen to him gripe every day about women, hangovers, or his "lousy" pay. To rub it in, Ruth, in his first year as a full-time fielder, had a spectacular season, setting a Major League record with 29 home runs.

On the last game of the season Ruth was a no-show, making his way to the west coast for a series of lucrative exhibition games where he mused out loud about—depending on the day—becoming a professional boxer, joining another baseball league, or going Hollywood if he didn't get $20,000 next year from the Red Sox.

Meanwhile, Frazee was having a lousy year. A couple of his productions were losers and he had to deal with the malcontents Mays and Ruth, the anti-Babe clubhouse, Ban Johnson, and the Loyal Five. And the country was going dry in January. He had to get a grip.

Frazee weighed his options: Cave into his slugger's obscene demands and double his pay, or unload the pesky diva and make some quick cash. On Boxing Day, December 26, 1919, Frazee and Rupert agreed, in private, to a deal that made Ruth a Yankee for $125,000 down. The New York owner also loaned Frazee $350,000 so he could buy, rather than rent, Fenway Park.

The deal went public on January 5, 1920—the Birth of the Curse.

For the Red Sox faithful, it was an unpardonable sin, yet they were the ones who would pay penance for it for the next 86 years. The Yankees, meanwhile, went on an otherworldly tear of 26 World Series championships.

And yet the Peorian wasn't finished plundering his championship team. In what appeared to be his Stream of Unconsciousness from 1920 to 1922, Frazee sent his 15 top players to the Yankees and most of them were huge factors in New York winning the American League pennant in 1921 and claiming its first-ever World Series title the following year. And the Babe? His career went. . . *Ruthian*—out of the park—with 54 homers in 1920, 59 in 1921, and 35 in 1922.

Back at Fenway, the stripped Red Sox bubbled below .500 in 1920 and 1921. The team hit its nadir on July 13, 1922, when 68 screaming fans cheered the last place Red Sox. Even Frazee couldn't stomach it anymore; that same month he sold the carcass for $1.25 million—almost twice what he had paid in 1916 for a great team.

On Broadway Frazee had the savvy to take a flop and make it a hit; in baseball, he proved he could take a hit and turn it into a flop. But why?

Over the years there have been a number of theories about the Babe Ruth trade. Frazee himself insisted it was all Ruth's fault because his overbearing personality caused a rift in the locker room and fouled any hope of team harmony.

Many believed that a cash-strapped Frazee sold Ruth to finance his play *No, No, Nanette*, until others pointed out that this, his most popular production, made its debut in 1925—five full years after the Babe sale.

However, Gil Stout, author of *Impossible Dreams: A Red Sox Collection*, argued that at the time of the sale, Frazee had a comedy, *My Lady Friends*, that ran from December 1919 until June 1920. Within a couple of years—coinciding with the sell-off of the rest of the Red Sox top dogs—Frazee decided to make a musical out of *Friends*, which after numerous rewrites, cast changes, and scoring revisions evolved into *No, No, Nanette* with its signature song "Tea for Two."

In 1923–1924, Frazee took the show on a pre-Broadway tour to London and then to Chicago, where it had a year-long run. *Nanette* had its Broadway debut in 1925 and was a wild success for the Peorian; it later went on a world tour—the very first show from Broadway to do so.

Also, in February 1920, a month after selling the Babe, Frazee bought the shaky Harris Theater on West 42nd Street and, after a costly renovation, renamed it the Frazee Theater.

One thing was certain—none of the Babe cash went to charity.

Red Sox fans weren't the only ones afflicted by the Curse of the Bambino; the man who started it all suffered too. For years the Boston sportswriters took swings at him. Even the nationally-renowned independent scribe Fred Lieb, who wrote the 1947 book *The Boston Red Sox,* railed against Frazee, starting with such subtle chapter titles as, "Evil Genie From Peoria Enters Picture" and "The Rape of the Red Sox."

During the years Frazee was busy trading away all his team's top talent to the Yankees, he hit the bottle even harder than before and began a slow crawl away from baseball and back to Broadway, his first love. According to Irving Caesar, who wrote the song "Tea for Two" for *No, No, Nanette,* "Harry Frazee never drew a sober breath in his life, but he was a hell of a producer. He made more sense drunk than most men do sober."

The Peorian who birthed the Curse and changed baseball forever died on June 4, 1929, in New York City from Bright's Disease, a kidney disorder. If he had lasted until October, no doubt some in the Red Sox Nation would have accused him of starting the Great Depression.

The Icing: Philip José Farmer

Already a science fiction icon, Philip José Farmer left America's heartland in the mid-1950s for the airy west coast. By 1970, he brought his fame back home.

"Peoria's as good a place as any to watch the world go to hell in a handbasket," he claimed.

Though not a native Peorian, Philip José Farmer has been one most of his life: the most prolific and famous writer in the town's history. Born in North Terre Haute, Indiana, on January 26, 1918, to George and Lucile Farmer, he was five when the family settled in Peoria. His father, a draftsman, worked for the streetcar company Illinois Power and Light.

Farmer had a youth of outdoors and books, and although he would become world-famous in the genre, it wasn't until he was a fifth grader at Columbia Grade School that he read his first sci-fi story, a novel by Chicagoan Edgar Rice Burroughs; the experience opened within him wild worlds of his own creation.

Moving through his teens, Farmer hadn't a clue that, when he graduated in 1936 from Peoria High, he would become the second-most famous alum of the 17th oldest public school in America. The most famous, according to his autobiographical piece "Maps and Spasms," was Betty Goldstein (class of 1938) who later, as Betty Friedan, wrote *The Feminine Mystique*.

His collegiate career didn't exactly follow a rhumb line to graduation; instead, he took a side-winding path to a 1950 degree in English literature from Bradley University. Soon, though, he would be on the fast-track to notoriety and ballyhoo.

Farmer was only two years out of college when the August 1952 issue of *Startling Stories* magazine, featuring his novella *The Lovers*, hit the newsstands and he became a force that flexed the genre of science fiction his way. The story included the first graphic description of a love scene between a human and an alien, a taboo Farmer shot to cosmic dust. The resulting chatter from readers and other writers alike assured the Midwesterner of sci-fi's version of the Pulitzer—The Hugo Award—as 1953's Newcomer of the Year. *The Lovers* was published as a standalone novel in 1961.

Around the same time as Farmer's breakthrough, another Illinoisan, Hugh Hefner, also broke taboos with his debut publication of *Playboy* in 1953. Was Philip José Farmer the "Hef of Sci-Fi," or was Hef the "Phil of Sex"?

Over the next five decades, Farmer would be nominated for Hugos five more times, winning twice: in 1968 for the story "Riders of the Purple Wage," and in 1972 for the novel *To Your Scattered Bodies Go*— the first of five books in his acclaimed Riverworld series. The Sci-Fi Channel aired the TV movie *Riverworld*, based on the series, in 2003.

For a lifetime of imaginative writing, the Science Fiction Writers of America named Farmer the 2001 Nebula Grand Master, along with the World Fantasy Award for lifetime achievement. He also received the Bradley University Centurion Award as a Distinguished Alum in 1996.

Far more importantly though, The Brando of Sci-Fi kept his typewriter clicking along for some 45 novels and hundreds of short stories, articles, and poems in a gumbo of styles. He would slipstream into fantasy, fictional biographies of Tarzan and Doc Savage, "true stories" involving heroes of his favorite authors, and even a mystery set in Peoria, *Nothing Burns in Hell*.

An interviewer once asked Peoria native Dan Simmons— himself an award-winning writer of horror, fantasy, science fiction, and crime novels—"Why do Midwest authors write in a variety of genres instead of concentrating in the field that first brought them fame?" Simmons replied that since Midwesterners grow up watching farmers rotate their crops, it was only natural that they should "rotate their genres."

The most publicized spat of Philip José Farmer's career happened even though he took extraordinary steps to prevent it. It was 1974 when he had the idea to write a story in the style of Kilgore Trout, a fictional sci-fi author created by Kurt Vonnegut as his alter ego who made appearances in his novels starting in 1965. Farmer pitched the idea, which included a possibility of a series of books under the Trout byline, to Vonnegut, who gave his okay—as long as no one would ever think *he* wrote them; Vonnegut's publisher also agreed to the proposal.

The result was "Venus on the Half-Shell" by Kilgore Trout, a two-part serial published in *Fantasy and Science Fiction* magazine beginning with the December 1974 issue. (It was published as a book in 1975.) There was an immediate hubbub as fans and the media tried to guess Trout's real identity. Most assumed it was Vonnegut tweaking the public, but he said nothing, which stoked the curiosity further.

When several reviewers gave Vonnegut high marks for *Venus*, he finally erupted and demanded that Farmer own up. Soon after, at a sci-fi convention, Farmer confessed—to applause.

Vonnegut would grouse on demand any time he heard the names "Venus," "Philip José Farmer," or even "Trout" mentioned, but the men actually had a lot in common. They had both worked at General Electric in upstate New York (Vonnegut in public relations from 1946 to 1952, and Farmer in technical writing in 1956), and they had a common breakout year in 1952 with the publication of Farmer's *The Lovers* and Vonnegut's first novel, *Player Piano*.

But a curmudgeon's anger dies hard.

Farmer and his wife, Bette, whom he met at Bradley and married in 1941, followed jobs around the country starting in the mid-1950s while the budding author continued to write part time. His eventual success and world fame allowed them to live wherever they chose, and they chose to come back to Peoria. Being able to write full time was the icing.

On the eve of their return to Peoria in 1970, their West Coast literati friends peppered the Farmers with the question "Why Peoria?" The Farmers always answered "Why not?"

The humble Peoria Icon died February 22, 2009, in the town of his youth where he saw wild-flung, exotic galaxies and took the rest of us along for the ride.

9. TERRORISM DOESN'T PLAY IN PEORIA

"The Duke" Without the Swagger

When terror reached America's shores on September 11, 2001, President Bush would soon tap a Peorian as his top savant on counterterrorism, the man who actually wrote the book on it: General Wayne A. Downing.

On September 12, less than 24 hours after the attacks, a C-130 Hercules from Peoria's 182nd Airlift Wing powered its way through the uncluttered sky while the country below mobilized for a new era of war.

Born May 10, 1940, in Peoria to Eileen and F. Wayne Downing, the future four-star general grew up on Brons Street in a modest home on the town's faceless west side. The idea of becoming a soldier came early to Wayne, who watched his father, his first hero, leave for war.

On March 27, 1945, the Army's famed 9th Armored Division fought its last major firefight of World War II: a nighttime bloodbath to liberate American prisoners of war from the prison camp at Limburg, Germany. During the attack, 25-year-old PFC Downing died 43 days before his son's fifth birthday.

Rather than retreat inward with grief or lash outward with bitterness at her husband's death, Eileen Downing did it right as she selflessly raised her son and two daughters into bright, personable, and well-adjusted adults. And when Wayne graduated from Spalding Institute in 1958 en route to the U.S. Military Academy at West Point, his mother didn't block his way, physically or emotionally.

Downing graduated from West Point in 1962 and went on to a 34-year fabled career, starting as an infantry platoon leader with the

173rd Airborne Brigade on Okinawa, moving on to two combat tours in Vietnam, and topping out as a four-star general and commander-in-chief of the United States Special Operations Command (tri-service) in 1993. While in the service, he also earned an MBA from Tulane University in 1972.

He retired in 1996 not only with the worldwide respect of his peers, but, more importantly, the love and admiration of all who served with or under him. They knew, in a hot zone, the unpretentious leader with rolled-up sleeves would never back down; he was the Rangers' Ranger, like John "The Duke" Wayne without the Hollywood swagger. And General Downing taught what he had done. As an Airborne—not chairborne—commander, he eschewed jumping a desk, preferring instead the forward action where he could take care of his troops. A fearless, wily thinker, he trained his elite forces the value of thinking ahead of the enemy and taught them that it's okay to drop in unexpectedly.

The general led an active retirement that left little time to weed a garden. He lived first in Colorado Springs before returning to his hometown, even though it appeared both towns served as little more than tarmacs for him and his satchel. The many tugs on his time included sitting on several corporate boards, founding the Combating Terrorism Center at West Point where he also taught and guided research on counterterrorism, and teaching seminars at the University Of Michigan School Of Business.

The strongest tugs, however, came from his country. When it came to terrorism, he was America's Man on Point.

In June 1996, soon after the general's retirement, a truck bomb killed 19 U.S. military personnel and injured 200 at Khobar Towers in Saudi Arabia. President Clinton appointed the Peorian, the leading counterterrorism expert in the country, to head a blue-ribbon Department of Defense investigation into the attack. His committee found that the entire military command chain failed to provide adequate intelligence and security. General Downing presciently warned that

"a persistent, not intermittent, terrorism threat exists" and concluded that there was "an undeclared war on the United States."

From 1999 to 2000, he worked as a member of the National Commission on Terrorism (the Bremer Commission) that looked into the threat of attack on the United States. The commissioners urged President Clinton to "pursue a more aggressive strategy against terrorism."

In other words, be aware-—stay frosty.

The general answered his last call to his country in the ashen days that followed September 11th when President Bush appointed him national director and deputy national security advisor for combating terrorism. As the principal advisor to the president on the most serious threats to the country, the Peorian pushed for tighter coordination between local, state, and federal agencies—even if it meant sharing information and assets.

In June 2002 the general resigned his post of eight months and returned home to tend to his garden of other commitments; he later added TV news military analyst to his list of responsibilities. The retired general imparted gravitas to NBC news programs; his commentary provided insights from someone who really knew the offstage world.

On Monday, July 16, 2007, back home in Peoria, the general swam laps at an easy pace—no double time today. It was a day without plans, a day that belonged to him.

But just hours later he found himself at Proctor Hospital, fighting for his life against an invisible foe, improbably contracted while swimming. He caught the bug in a pool and not in some backwater in the remote recesses of the globe.

Early on Wednesday morning, July 18, 2007, General Downing died. His death was caused by a complication of bacterial meningitis and an immune system weakened by underlying multiple myeloma.

When the news of his death reached the world, warriors in the shadows cried in their own way.

On Friday, October 10, 2008, the city of his birth honored Downing by renaming its airport the General Wayne A. Downing Peoria International Airport.

Known as "the most famous general no one ever heard of," Downing received another posthumous and public outpouring from his hometown when, on November 20, 2008, Peoria held a dedication at the Civic Center for the General Wayne A. Downing Veterans Home.

For the unassuming general, the Duke without the Swagger, it didn't get any better than that; after all, it was always all about taking care of his troops.

At the White House on December 10, 2008, Kathy Downing accepted on behalf of her late husband the Presidential Citizen Medal from President George W. Bush. The rarefied medal, given only to a select 100 civilians since 1969 and second only to the Presidential Medal of Freedom, recognized the general's high-value, but short, civilian service to the nation.

When Stand-Up Didn't Play in Peoria

Even in America's Hometown, the City of Comics, September 11th brought shock and foreboding. But thanks to a Peoria police officer, an alleged key figure in a "Second Wave" attack plan wound up cuffed.

And it all started with an innocent stand-up.

It was two afternoons after the attacks against America, Thursday, September 13, and Officer Greg Metz of the Peoria Police Department was on patrol, cruising south of Northwoods Mall on Sterling Avenue. That's when he noticed the car in front of him: a youngster was standing up on the back seat, staring at him through the rear window. Though he may have been tempted to wave hello, Officer Metz knew it was a serious safety risk to have a child not in a car seat. As he readied to pull the maroon compact over, the child pointed toward

him and said something to the driver, who slowed down and made a right turn, without signaling, just south of the Sterling Plaza onto Reservoir Boulevard—infraction number two.

The patrol car stayed behind the creeping westbound car until the driver rolled through a stop sign. That did it. The lights went on and Officer Metz gestured for the driver to pull over, but the car drove further until it stopped at the curb of a house for sale.

When he walked up to the car, Officer Metz saw a well-groomed, clean-shaven man who could've been a Caterpillar engineer from the Middle East; he was polite and spoke excellent English. After the driver heard the three strikes against him he surrendered his license, which the officer checked through the Illinois DMV. The run-through stirred up a 10-year-old DUI warrant for the driver, Ali Saleh Kahlah al-Marri; a legacy of his undergrad party days at Bradley in the early 1990s.

At the same time, al-Marri left his car and went over to Officer Metz and asked if he could look around the house with the for-sale sign; with the child still in the car, a breakaway seemed absurd, so the officer nodded "okay."

"I'm thinking of renting this house," al-Marri said when the policeman caught up with him in the backyard. In double-time chatter, he said he had a construction company with his brother in his home country of Qatar and that he was back at Bradley University for graduate work. The officer, when the driver took a breath, told him about the outstanding warrant and that he'd have to post a $300 bond, along with a jail stay. The real fret for Officer Metz, even though it would be a matter for Family Services, was the child, the stand-up in the backseat, who appeared to be about six. What would happen to him when his father went to lockup? al-Marri solved the problem by saying that he and his wife were staying at the East Peoria Super 8 motel.

A Tazewell County deputy met them at the motel where, outside the room, al-Marri talked to the closed door in his native tongue.

The door opened, and they walked in. The room seemed uncluttered except for another car seat on the floor. "My wife just had a baby," he explained, though it seemed obvious that wife and baby were hiding in the bathroom.

Then, oddly, al-Marri plopped a leather briefcase onto the bed and opened it to reveal stacks of hundred-dollar bills; the DUI-jumper calmly skimmed off the $300 for the bond and closed the case. Later, Officer Metz said it was like a scene out of *The Godfather*.

From there they went to the Peoria station, where al-Marri was taken to the Peoria County Jail; it was the last time Officer Metz would see his collar, the one with the stand-up son.

But it wouldn't be the last time he, or the world, would *hear* of al-Marri.

This stop, out of the policeman's 32,000 previous ones, clanged with uneasiness for Officer Metz, enough so that he called the police liaison to the Peoria FBI office that night at home and reviewed the arrest. As cryptic as possible, the agent said there "might be something" and that he'd pass it on.

And it was "something."

Ali Saleh Kahlah al-Marri has been in custody since December 11, 2001, on charges of credit card theft, lying to the FBI, and being a material witness in a terrorism investigation.

On June 23, 2003, President Bush declared al-Marri an "enemy combatant" and dropped all federal charges against him at the federal court in Peoria. The case against the alleged al-Qaeda bagman, the only enemy combatant captive on American soil, remained a sidewinder in the courts.

All this from an alert Peoria police officer who—as former Attorney General Ashcroft put it in his book *Never Again*—spotted the "spit on the sidewalk."

Soon after returning to Peoria on September 11, 2001, on a student visa ostensibly to attend his alma mater Bradley University (the Qatar–

Peoria Milk Run), al-Marri's life as an al-Qaeda mole in Midland America unraveled. However, it'd take over seven years and a return to his American home of Peoria for him to confess his guilt.

On April 30, 2009, in a plea agreement before the U.S. District Court, he acknowledged he was a trained member of al-Qaeda and pleaded guilty to abetting the terror network; in fact, the one-time America's only enemy combatant-designee, whose status changed in February of 2009 when a Peoria federal grand jury indicted him on aiding terrorism charges, told how the September 11th mastermind Khalid Sheikh Mohammed himself asked him, in 2001 at an al-Qaeda training camp in Pakistan, to return to the United States no later than September 10 to "further their terrorist objectives."

The plea decision probably had more to do with the evidence against him than a desire to spare American jurisprudence time and money. Among other things, al-Marri's laptop was overwhelmingly dirty with terrorist-friendly info on cyanide gas and other volatile, deadly gas formations.

And his major wasn't chemistry.

Going guilty also improved his outlook; throughout the court session al-Marri was the affable accused. But years before, on June 23, 2003, during his "enemy combatant" transfer to federal marshals at the Peoria Airport, Peoria Air National Guard security force commander Major Josh Hendrix saw a very different face, one with the scalding hate of a potential killer.

Or maybe the confessed terrorist was just happy to be back in America's Heartland.

The Peoria area has a number of military reserve units that have had significant impacts on the nation's security throughout history, but especially in the era of world terrorism. Missed chances can have a positive valence such as terror not playing in your backyard, town, or country. And the local reserves with their citizen soldiers have had meritorious accomplishments

of global importance.

The profiles that follow highlight just a few of the reserve units that call Peoria home. In truth, they all deserve to have their stories told.

Against all Hell

Ever since General George Washington appointed the Continental Army's first wagon master, the movement of men and materiel by Army transport has had an important, but *supportive* role in combat. That changed in the sandpit of Iraq when the insurgent guerillas made coalition convoys their primary targets.

The Army Reserve 724th Transportation Company, based in Bartonville, west of Peoria, began in Chicago in 1948 and faced its first activation on New Year's Eve 1948. Its mission is to provide combat support in the manner of transporting U.S. forces and materiel. After several moves and activations, the unit moved to northside Peoria in 1972 and finally to Bartonville in 1991.

Its fateful, last mobilization to active duty was December 12, 2003 to February 27, 2005 in Iraq.

It wasn't long before the troops of the 724th knew why their base at Balad had nicknames like "Mortaritaville," "Bombaconda," and "Big Snake." The daily mortar lobs, the bombapalooza, against the Logistics Support Area gave it away. The company ran security for fuel-hauling convoys from Balad to Baghdad, usually to the airport. It was an hour-and-a-half gauntlet with a high pucker factor.

On Good Friday, April 9, 2004, around 10:30 a.m., a 26-vehicle convoy rolled past the green zone and into the red zone, the outside world, with five gun trucks and two armed convoy command humvees guarding 19 civilian fuel trucks (unarmed tankers employed by Halliburton subsidiary KBR—Kellogg, Brown, and Root) on an emergency mission to deliver 125,000 gallons of fuel to the north gate of Baghdad International Airport along Alternate Supply Route

"Sword." The entire in-country U.S. military was on edge, and not just because it was Good Friday; it was also the one-year anniversary of the fall of Baghdad.

And it was a Muslim holy day.

Yet despite intelligence about an increase in insurgent militia attacks against convoys, the threat alert level for the Sword route remained at "Amber"—maintain wariness—rather than the more ominous "Red," or "Black," the mission-stopper. However, a recent Army policy change allowed soldiers to ride shotgun with the civilian truckers for added security.

After the convoy was long past recall, Army Intel upgraded Route Sword's threat level to "Black."

The convoy reached Abu Ghraib around noon without incident and traffic seemed normal enough, if "normal" meant that every car that passed was a potential bomb threat. Yet with five miles to go, the trucks and tankers approached a surreal patch of north Baghdad—no cars, no people, no life.

The Americans were in the eye of a hurricane.

As First Lieutenant Matt Brown, the convoy commander in the lead humvee, scanned the empty road ahead, he sensed either an ambush or a road full of IEDs, improvised explosive devices. When he saw a local running away from the road ahead, he yelled to his crew, "Hey, I think we might be in trouble."

About two miles behind in a humvee at the convoy's tail, Sergeant First Class Robert Groff, the assistant convoy commander, heard Lieutenant Brown call out that they were under small arms fire, then radio silence.

Seconds later the eyewall of the hurricane hit, as the largest coordinated insurgent ambush of Operation Iraqi Freedom slammed into the convoy. The fusillade of rocket-propelled grenades and machine gun and rifle fire from 200 to 250 insurgents of the Madr Militia blew open a four-mile kill zone around the outmanned and outgunned Americans.

With death hanging over each of them, the soldiers of the 724th met the barrage with one of their own as they laid down suppressing fire. Meanwhile, the drivers pushed their vehicles to the limit as they weaved around concrete blocks that littered all three lanes of the highway

Help, in the form of the 12th Cavalry Regiment, was four miles away in an abandoned milk factory, though neither unit knew about the other. The cavalry had engaged another band of insurgents only hours before, but quickly joined forces with the central Illinois unit when they saw the lead vehicle, driven by Specialist Jeremy Church, rattling toward their compound on three wheels and a tire rim. Several convoy vehicles soon followed, but most of the tankers were leaking fuel or disabled back on the highway.

The cavalry sent a couple of Bradley Fighting Vehicles, uparmored humvees, and Abrams tanks into the fray to provide cover. Specialist Church, after ensuring the quick medevac of Lieutenant Brown, who suffered catastrophic left eye and head injuries from a bullet in the first minutes of the ambush, rode back into the action with the cavalry and helped evacuate the wounded.

At the back of the convoy, under heavy enemy fire and with no radio contact, Sergeant Groff mulled his options: stay and fight or make a run for possible cover up the road. His humvee, hammered by gunfire, had ground to a halt on the oil-slicked road; it was also carrying eight wounded men whom Groff had rescued. With his driver and on-top gunner, he had 12 men in a vehicle with a maximum capacity of five, so he couldn't risk open exposure. They stayed and fought in the sitting duck, using machine-gun fire to keep the insurgents from circling their vehicle.

Suddenly the enemy fire slackened at the approach of the cavalry and their supporting fire; the ambush was over.

At the milk factory, the men of the 724th and the KBR truckers counted off. PFC Gregory Goodrich and KBR driver Steven Fisher had died and nine others were missing—two soldiers and seven KBR

civilians. Just after the battle, a videotape surfaced showing KBR convoy commander Tommy Hamill in a car with his captors.

Their fates, except for one, unfolded over the next four years.

Four days after the ambush, on April 13, troops recovered four men from a ditch a few miles west of the attack: Sergeant Elmer Krause, Jeffrey Parker, Steven Hulett, and Jack Montegue.

One week later, on Friday, April 16, Al Jazeera TV broadcast a video showing the 724th's PFC Keith "Matt" Maupin sitting on a floor with his hooded captors around him; the Army switched his status from Missing In Action to Prisoner of War.

On April 18, remains found in Baghdad were identified by DNA as KBR driver Tony Johnson.

On May 2, 23 days after the attack, the captive Tommy Hamill heard a faraway rumble of military vehicles from inside his airless, windowless cell. He broke for daylight, running barefoot across a rocky, dusty field to the road a half-mile away. After catching his breath, he led the soldiers back to the hut where they captured two of his guards.

His escape proved to be the only happy ending for the MIAs.

On June 28, Al Jazeera aired another tape from the insurgents that showed a mob-style shooting to the back of the head of a blindfolded soldier they said was PFC Maupin. Because of the grainy video quality, officials couldn't make a positive identification and the military kept hunting for the reservist from the 724.

In January 2005, a recovery team discovered the remains of KBR's William Bradley in Baghdad.

Years later, with the fourth anniversary of the ambush looming, all hopes and prayers for Matt Maupin met a tragic end when his remains were found on March 20, 2008, some 12 miles west of the ambush site.

The last unknown regarding the bloody ambush is the status of KBR's Timothy Bell. Aged 61 at the time of his capture, his is the second longest MIA of Operation Iraqi Freedom.

Three soldiers and six civilian contract workers died as a result of the ambush: PFC Gregory Goodrich, 37; Sergeant Elmer Krause, 40; Sergeant Matt Maupin, 20; Steven Fisher, 43; Jeffrey Parker, 45; William Bradley, 50; Jack Montegue, 52; Steven Hulett, 48; and Tony Johnson, 47. Seventeen members of the convoy suffered wounds or injuries. The total casualties of 27, including MIA Tim Bell, accounted for 43.5 percent of the convoy force.

Of the 26 vehicles that left the green zone, only seven or eight limped into the cavalry's safe zone; all sustained damage.

The ferocity of the attack was over ten to twenty times greater than the typical ambush of 10 to 20 enemy fighters.

Tragedy in the Morning

After a February 2003 federal mobilization, the Chinook helicopter unit Company F 106th Aviation of the Illinois Army National Guard based in Peoria arrived in-theater at Kuwait City in April; they later deployed to Balad, Iraq, just north of Baghdad.

Sunday morning, November 2, 2003, was a day that no member of the unit would ever forget.

It started as a routine mission: Fly 3rd Armored Cavalry Regiment troops, who were going on stateside leave, to Baghdad International Airport for an Air Force flight home. The assignment called for two Chinooks.

The two choppers lifted off from Al Asad Airbase in Balad in the early morning, heading east toward Ramadi and Fallujah, where they were to pick up more passengers. Leaving Fallujah around 9:00 a.m., the Chinooks continued east with one stop left—a place called St. Mere, just west of Baghdad.

About nine miles out from Fallujah, in an area known as Date Palm Grove, three insurgents hid in the scrub and waited. When the lead aircraft flew by, they fired their surface-to-air missile. The heat-seeking

missile locked on to the slow, low-flying Chinook, and the helicopter's defensive automatic flare dispenser failed to deploy.

The missile homed in and blasted the number two engine.

With smoke engulfing the cabin, the Chinook crew tried landing their aircraft safely, but the ragged terrain made that impossible. The helicopter crashed in a creek bed.

The second Chinook radioed for help and touched down, but the crew kept the rotors turning while all their passengers and the door gunner raced to the crash site to help the injured in the downed aircraft.

Within an hour, attack helicopters blanketed the area with security as medevac Blackhawk helicopters, with the aid of the soldiers already on the ground, whisked the injured to area hospitals. Because of the number of casualties, the remaining Chinook carried 11 of the injured to Baghdad Hospital.

Three of the Chinook's five crewmembers, who were a mix of Peoria and Davenport soldiers, along with 13 soldiers of the 3rd Armored Cavalry, died from what officials later called a "lucky shot." That shot also injured another 25 soldiers.

The three members of Company F killed that day were Pilot in Command CW4 Bruce A. Smith, 41, of West Liberty, Iowa; Pilot 1LT Brian D. Slavenas, 30, of Genoa, Illinois; and Flight Engineer Sgt. Paul F. Fisher, 39, of Cedar Rapids, Iowa. (Sergeant Fisher died four days later at a hospital in Germany.)

After the tragedy, the remaining Chinooks received newer flare dispensing systems. For the rest of their deployment the unit shifted to nighttime sorties without further incident, and the unit returned home to Peoria and Davenport in late June, 2004.

In August 2006, Company F 106th Aviation of the Illinois Army National Guard at Peoria became Company B, 2-238th General Support Aviation Battalion. The unit is due to deploy to Afghanistan in early 2009.

We Are Ready

April of 2008 marked the 50th anniversary of the U.S. Marine Corps Reserve unit in Peoria. Engineer Company C's roots go back to 1948 when it was part of the 8th Infantry Battalion. Back then, the World War II veterans held monthly drills at the downtown Lincoln Elementary School.

The Peoria reservists responded to their first call to active duty in 1950 with the outbreak of the Korean War. Later they became the 19th Special Infantry Company; in 1960, they were the 79th Rifle Company.

A major mission shift occurred in 1962 when the unit, after engineer schooling, became the 14th Engineer Company. In 1976 they became Engineer Company C, 6th Engineer Support Battalion, 4th Force Service Support Group.

The unit stands by its motto: We are ready.

From January 11 to June 6, 2003, Engineer Company C supported the frontline missions of Operation Iraqi Freedom when they, along with other companies of the 6th Engineer Support Battalion, set down 60 miles of bulk fuel lines into Iraq—an unprecedented feat in Corps history. The fuel lines are six times longer than the previous longest fuel system in a combat zone.

The history-making 6th ESB Marines also accomplished their mission in half the time—three days—and during the region's worst sandstorm in over 20 years. In addition, Peoria's Marines secured a number of various water purification sites for the coalition.

The unit returned to Iraq in July of 2004 to provide construction for Regimental Combat Team 7. Company C also handled logistical convoys for Combat Service Support Battalion-7 and anti-tank mine search-and-destroy details. They returned to Peoria in March of 2005 and mobilized again in May of 2007.

Engineer Company C lost three Marines during Operation Iraqi

Freedom: Corporal Evan T. James, Sergeant Bradley S. Korthaus, and Corporal Joshua D. Palmer.

Prairie-Prepped

The Navy and Marine Corps Reserve Center in Peoria trains assigned naval unit members for active duty mobilization for any exigency, including war, natural disasters, or any other operation.

The Naval Reserve has had a presence in Peoria since 1912 when a voluntary group of Spanish-American War veterans formed the 8th Naval Militia Division. The three officers and 50 enlisted men drilled at the YMCA until activated for World War I.

By 1950, the Peoria Naval Reserve was 400 strong and had its own training ship, a Landing Ship, Infantry (troop transport), the USS LSI-596, on the Illinois River.

In 1977 the Naval Reserve moved to its current location on Plank Road. It is made up of Unit Fleet Hospital, Great Lakes, Detachment 13; Naval Mobile Construction Battalion 25, Det. 1725; NTC Great Lakes, Det. 1367; Naval Operational Support Unit, which used to support the Pearl Harbor Naval Station but now has a global mission; Voluntary Training Unit, Det. 1613, senior officers who voluntarily provide training for junior officers; and Medical Battalion Support, corpsmen and chaplains to the Marine Corps. Peoria is home station to 160 reservists and 10 active duty personnel.

The Navy reservists from Peoria have served in every conflict since World War I, adapting to the changing faces of war. After September 11th, training shifted to an operational emphasis dependent on the theater environment.

The Naval Mobile Construction Battalion 25, the Seabees, has had the most mobilizations, most recently in the fall of 2006 when they participated in rebuilding the infrastructure of Basra, Iraq.

The Peoria Naval Reservists are prairie-prepped and world-wide ready.

The Peoria Air Guard Delivers

From its first taxi at the Greater Peoria Airport on June 21, 1947 as the 169th Fighter Squadron, the Peoria Air Guard has grown in stature as one of the top C-130 Hercules units of the Air Force's Air Mobility Command. Over the past half century, the unit has flown an impressive array of aircraft with its changing missions, starting with P-51 Mustangs from 1947 to 1956 and the Hercules from 1995 to the present.

The 169th Airlift Squadron, 182nd Airlift Wing, Illinois Air National Guard Peoria boasts eight C-130 H3 aircraft that are capable of any assignment, anywhere in the world.

They are always ready to make the ultimate sacrifice, as evidenced by SSgt. Jacob L. Frazier of St. Charles, Illinois. On March 29, 2003, north of Geresk, Afghanistan, Frazier died of wounds suffered in an ambush; he was part of a Special Forces unit. The 24-year-old was posthumously awarded the Bronze Star for Valor and the Purple Heart.

Following are brief examples of some of the unit's recent adventures while serving their country in the name of Peoria.

On March 21, 2003—the second night of Operation Iraqi Freedom—A Peoria Air National Guard C-130 flew north from Kuwait; somber paratroopers of the Army's 82nd Airborne on board in the darkened cabin listened to the loud thrumming of the Herc.

The aircraft crossed into Iraqi airspace, which looked a lot like Kuwaiti airspace. So far, so good. The transport flew completely blacked-out over enemy territory, the crew's night vision goggles picking out details as far away as the horizon.

That night, for most of the flight, the horizon had offered little to see, even with night vision, since most of the country was without electrical power.

Until the flight engineer asked, "Hey, are there supposed to be storms around Baghdad?"

The pilot, Lt. Colonel Steve Konie, said, "Yeah, so?"

"Looks like a lot of lightning ahead," the engineer replied.

"That's not lightning. That's the war," Konie said. "Tomorrow's forecast will be mostly war, too."

The fog of war rolled in later.

On April 27, 2003, seven members of the Peoria Air Guard flew the first American plane into Baghdad International with the first interim Iraqi government aboard.

Given the callsign Glide-77, the C-130E, affectionately known as "63-872" by the Guard, rolled on the runway at the United Arab Emirates' al Minhad air base around mid-morning for an eye-blink jump over the Persian Gulf to Qatar. Moments later, Major Dean "Dino" Meucci, the aircraft's commander, throttled up and the Hercules headed north in a climbing bank.

In less than an hour, the crew met their distinguished visitors at the al Udeid air base terminal. Even for VIPs, this group of a dozen civilians had gravitas: they were all members of the interim Iraqi government known as the Office for Reconstruction and Humanitarian Assistance that would oversee the transition to a freely-elected government in Iraq.

The crew and its self-loading cargo took off through desert haze for the second, two-hour leg to Baghdad. The visitors seemed quite at home with the cabin's spartan digs and the art of shouting conversation over the plane's roar; in his role as liaison, Squadron Commander Lt. Colonel Steve Konie found out why: most, if not all, of the new Iraqi governors were former military.

They also knew theirs was a dangerous game. Though the war phase of Operation Iraqi Freedom had ended over 18 days before, pockets of guerillas remained throughout the country and were still capable of wreaking murderous havoc. The bushfighters with rockets targeted low-flying U.S. aircraft, increasing the risk of daytime sorties "inside the box," or Iraq.

With that in mind, the delivery of the interim government involved additional veils of secrecy, including which Baghdad airport the flight would land at. Until now, all coalition flights used the heavily-secured Baghdad Military Airport, and the Peoria C-130 seemed headed for a routine landing there. But as the Herc began its approach, it descended undetected toward the International airport. After avoiding bomb craters during the landing, the plane taxied to the specified terminal and, in another ordered break from the standard operating procedure for offloading with the engines running, the Peoria crew shut the Herc down. From a cabin window, Squadron Commander Konie had his first ground-level view of an airport that almost all coalition pilots had observed only from altitude, as they dropped their bombs on it.

It had a ghost town look: sandstone buildings, dust, and no signs of life.

In less than a blink of an eye, a dozen or more men in civilian suits and carrying obvious automatic weapons surrounded the plane. Moments later, the aft ramp and door cranked open and several of the ground security guards scurried in and escorted the officials off the Herc.

After their historic delivery, the Peoria crew went on a nickel tour of the airport. The tour lasted only a few minutes, but the Peorians managed a priceless photo of its pilots holding a Southwest Airlines banner under the large sign, "Welcome to Baghdad International."

In the afternoon haze that followed the morning haze, 63-872 made the record books again, this time as the first U.S. plane to depart from Baghdad International Airport.

The Guard delivered.

Before dawn on Friday, December 26, 2003, a catastrophic earthquake of 6.6 on the Richter Scale nearly destroyed the dusty city of Bam in the southeastern Iranian province of Kerman. Estimates placed the number of dead at 26,000 out of a population of 90,000, or about 29 percent of Bam's citizenry—an unqualified, major disaster without even counting the estimated 30,000 injured from the quake.

Much of the town crumbled to rubble, including the Bam Citadel, which was more than 2,000 years old and had been touted as the world's largest adobe structure. As sepsis threatened the health of the survivors, a distress call went out to the world.

On Sunday, December 28, two days after the disaster, a Peoria Air Guard C-130 departed from Kuwait, roaring east toward Iran; a route seldom traveled by American aircraft. In fact, no U.S. military plane had flown into Iranian airspace in almost 23 years—since January 20, 1981, when Freedom One, an Air Force Stratoliner, whisked away the 52 U.S. embassy workers held hostage in Iran. It took an earthshaking tragedy to bring civility to American-Iranian relations.

The Hercules landed at Kerman, Iran, and began to offload its humanitarian payload, which consisted of 20,000 pounds of medical supplied in five pallets, with the help of Iranian soldiers.

A number of U.S. aircraft followed the historic lead of the Peoria Air Guard in the relief effort, but the two countries eventually resumed their non-diplomatic relations.

In April 2007, a few days after the discovery of the largest Soviet-era mass grave of 400 Afghan civilians in the Qorogh desert hinterlands outside Faizabad, Afghanistan, a C-130 of the Peoria Air Guard rolled out to a Bagram Airfield runway, its props spinning and ready for "Go."

Fifteen minutes later and on the ground in Kabul, the Afghan capital, the Peoria-based crew of six noticed tight security at the airport, especially the gunners atop all the terminal buildings; it was a fitting reception for their distinguished visitor: Hamid Karzai, president of Afghanistan.

When President Karzai arrived with his staff, the crew offered him a seat in the cockpit; he declined, saying his staff deserved the ride up front. He then sat in the back, the "cheap seats."

The plane flew northeast toward Faizabad—only 25 kilometers from China—with an A-10 Thunderbolt on each wing to provide close-

air support; the presence of the Warthogs emphasized the seriousness of the mission. In an hour all three planes began their descent into the always challenging Faizabad airfield, which sat in a narrow valley whipped by crosswinds; the aircraft skimmed the mountainside during the entire approach.

Before the flight back to Kabul, President Karzai spent time relaxing with the crew, recalling a one-time stopover in Peoria on the way to "somewhere" after a business meeting in Chicago. Then it was back to the real world.

When the C-130 taxied to a halt at Kabul, the gracious Afghan president thanked the crew over and over for the ride.

EPILOGUE

History is indeed little more than the register of the crimes, follies, and misfortunes of mankind.
—Edward Gibbon, British historian

The Peoria presented through these stories had a long, resilient history forged by its human and natural resources.

Peoria had its conception south of the equator and followed the rest of Laurentia in a world-rattling migration to a northerly clime, settling for a time on the west bank of the early Mississippi River. The bulging cliffs and steep canyons of the area underwent their last change when the glaciers lumbered through and created the landscape of today; the ice sheets also pushed the Mississippi west—the Illinois River then backfilled the fossil channel.

Peoria's Age of Man began with a large confederation of Native Americans who lived in the area, generally in serenity with their surroundings, for thousands of years. The discovery of Fat Lake in the mid-1600s by the Europeans changed everything.

From a tiny fur trading outpost to a small village to a major river port by the mid-1800s, Peoria evolved into a city that came to mirror the country with the choices made by its people. Some decisions may have even followed false echoes. Even so, a look at the missed chances of the past shouldn't be learning's third rail.

Given the universality of the uber-phrase "Will It Play in Peoria?" (which most cities would die for), Peoria has had unlimited opportunities to put a glowing spin on its soiled self-image.

It still does.

It is very hard to remember that events now long in the past were once in the future.
—Frederick W. Maitland, British historian

BIBLIOGRAPHY

For background on Peoria's vast history, we used the resources at both the Peoria Public Library and the Bradley University Special Collections Library, along with the interviews mentioned in the Acknowledgements.

Ashcroft, John. *Never Again.* New York: Center Street, 2006.

Berg, Scott A. *Lindbergh.* New York: G.P. Putnam's Sons, 1998.

Battlefield Diaries: Baghdad Convoy Attack. Discovery Communications, 2008.

Blackman, Ann. "The Friedan Mystique." www.time.com/time/magazine/article/0,9171,996777,00.html

Bugliosi, Vincent, and Curt Gentry. *Helter Skelter: The True Story of the Manson Murders.* New York: W.W. Norton & Company, 2001.

Cassagneres, Ev. *Ambassador of Air Travel: The Untold Story of Lindbergh's 1927–1928 Goodwill Tours.* Missoula, Montana: Pictorial Histories Publishing Company, 2006.

Cheney, Lynne Vincent. "Robert Ingersoll the Illustrious Infidel." www.americanheritage.com/articles/magazine/ah/1985/2/1985_2_81.shtml

Cook, John W., and James V. McHugh. *A History of the Illinois State Normal University.* Bloomington, Illinois: Pantograph Printing and Binding Establishment, 1882.

Davis, Kenneth S. *The Hero Charles A. Lindbergh and the American Dream.* New York: Doubleday, 1959.

Drake, Barbara Mantz. "Liberty's champion." Peoria *Journal Star.* February 21, 1999.

Driscoll, Jerry. "Corrington University: It Might Have Been."

East, Ernest E. *Abraham Lincoln Sees Peoria*. Peoria: Record Publishing Co., 1939.

————. *History of Peoria*. Unpublished.

Friedan, Betty. "Betty Friedan and the Women's Movement: Finally, They Play in Peoria." *Minneapolis Tribune*. November 24, 1978.

Gatto, Steve. "Wyatt Earp was a Pimp." *True West*. July 2003.

Kinison, Bill, with Bill Delsohn. *Brother Sam: The Short, Spectacular Life of Sam Kinison*. New York: Harper Collins Publishers, 1994.

Kravitz, Andy. "President Gives Downing Elite Medal." Peoria *Journal Star*. December 11, 2008.

————. "Al-Marri Admits Terrorism Plot." Peoria *Journal Star*. May 1, 2009.

Leiby, Richard. "The Secret Warrior." www.washingtonpost.com/ac2/wp-dyn/a55417-2001nov19

Lieb, Fred, and A.C. Silverman. *The Boston Red Sox*. Carbondale, Illinois: Southern Illinois Press, 2003.

Lindbergh, Charles A. Jr. *We*. New York: Putnam Publishing Group, 1927.

————. *Spirit of St. Louis*. New York: Charles Scribner's Sons, 1953.

"Lindbergh 'Fathered Two Families.' " http://news.bbc.co.uk/2/hi/europe/3249472.stm

Luciano, Phil. "A Comedic Genius." Peoria *Journal Star*. December 12, 2005.

————. "Peoria Bellboy to Blame for Red Sox Curse." Peoria *Journal Star*. October 22, 2004.

Marshall, Helen E. *Grandest of Enterprises: Illinois State Normal University*. Chicago: Lakeland Press, 1956.

"The Microphone of God." www.time.com/time/magazine/article/0,9171,947144,00.html

"The Mind of Manson." Peacock Productions, 2007.

"A New Black Superstar." www.time.com/time/magazine/article/0,9171,915319,00.html

Pensoneau, Taylor. *Brothers Notorious: The Sheltons*. New Berlin, Illinois: Downstate Publications, 2002.

Pryor, Richard, and Todd Gold. *Pryor Convictions: And Other Life Sentences*. New York: Pantheon Books, 1997.

Reeves, Thomas C. *America's Bishop: The Life and Times of Fulton J. Sheen*. New York: Encounter Books, 2002.

————. "Fulton J. Sheen, Catholic Champion." www.fultonsheen. com/Archbishop_Fulton_Sheen_biography.cfm

Rhoads, Mark. "Illinois Hall of Fame: Fulton J. Sheen." http:// illinoisreview.typepad.com/illinoisreview/mark_rhoads/index.html

Schröck, Rudolph. "The Lone Eagle's Clandestine Nests: Charles Lindbergh's German Secrets." www.atlantic-times.com/archive_detail. php?recordID=236

Schultz, Suzanne M. *Body Snatching: The Robbing of Graves for the Education of Physicians in Early Nineteenth Century America*. Jefferson, North Carolina: McFarland Press, 2005.

"Sergeant First Class Robert Groff, America's Army Real Hero." www. americasarmy.com/realheroes/index.php?id=8&view=bio

Stout, Glenn, Richard A. Johnson, and Dick Johnson. *Red Sox Century: The Definitive History of Baseball's Most Storied Franchise*. New York: Houghton Mifflin Books, 2005.

Trout, Kilgore. *Venus on the Half-Shell*. Cutchogue, New York: Buccaneer Books, 1975.

Wilson, John L. M.D. "Stanford University School of Medicine and the Predecessor Schools: An Historical Perspective." http://elane. stanford.edu/wilson/index.html

"Wyatt Earp's Lost Year." www.historynet.com/wyatt-earps-lost-year.htm

"Wyatt Earp was a Pimp in Peoria." www.clantongang.com/oldwest/ pimpinpeoria.html